FUNDAMENTALS
of
FIGURE CARVING

Books by the same author

Techniques of Creative Woodcarving
Projects for Creative Woodcarving
Relief Woodcarving & Lettering

In preparation

Fundamentals of Animal Carving

FUNDAMENTALS
of
FIGURE CARVING

IAN NORBURY

LINDEN PUBLISHING INC
FRESNO, CALIFORNIA

For Kerry and Theresa,

Baron and Baroness Hamer of Alford.

'Inventas aut qui vitam excoluere per artis,
Quique sui memores alios fecere merendo'

Virgil

*(who ennobled life by arts discovered; with
all whose service to their kind won them
remembrance among men.)*

© 1993 Ian Norbury

Library of Congress Cataloging-in-Publication Data

Norbury, Ian.
 Fundamentals of figure carving / Ian Norbury.
 p. cm.
 Includes bibliographical references.
 ISBN 0–941936–26–0 : $31.95
 1. Human figure in art. 2. Wood-carving--Technique. I. Title.
NK9704.N66 1993 93–31545
731'.82--dc20 CIP

Published 1993 by
Linden Publishing Inc.
3845 N. Blackstone
Fresno CA 93726

Printed in Great Britain

Acknowledgements

I would like to thank Jayne Norbury, James Norbury and Simon Westcarr for their patience as models; the staff at The Darkroom for their cooperation and photographic processing expertise; Miss D.A. Albersen, Mr & Mrs M. Boers, Mr & Mrs B.J.L. Davies, Mr & Mrs C. Fearn, Mr & Mrs M. Fraser, Mr & Mrs R. Sales, Mr J. Homer, Mr & Mrs K.P. Kelly, Mr & Mrs A.E. Brookes and Mr & Mrs G.M. Thomson for permitting their sculptures to be illustrated.

Contents

Introduction

FOR fifteen years I have been trying to carve representations of the human figure in wood. I have drawn and carved from live models, studied anatomy books and photographs by the dozen and carved scores of figures. It has been an uphill struggle and I believe I am now getting the hang of it. But why is it so difficult when all of this information is available and we are surrounded by bodies? Why do I get students on my courses who have been artists, carvers or even surgeons for half a century and yet could only model the most rudimentary representation of an ear or a knee? When a doctor can tell you the name and function of every component of the hand, why can he not visualise it as a three dimensional object and reproduce a reasonable likeness of it in wood or clay?

I feel that there are two main reasons. Firstly, I think the vast majority of people see two dimensionally, after all they live in a world of two dimensional representation on paper, on television, in the cinema and so on. Rarely is one's eye called upon to assess the form and volume of an object and the language does not cater for it. The vase in front of me is about 300mm/12″ tall and circular, consisting of a series of turned sections, some convex, some concave, some square, piled one on top of another into a familiar antique vase shape. The turned sections I can observe and recognise by their outline on the profile of the vase. It would contain perhaps a pint, or so many cubic inches of water. None of this tells us very much about its three dimensional form in space. I would have to give a long description using perpendicular comparisons or mathematical trigonometry to describe it — a cylinder squeezed in the centre

flaring out slightly at each end attached to a hemisphere (that is, not quite hemispherical, with about ⅓ cut off flat).

If it is so difficult to describe a regular object made on a lathe, how much more so for an irregular organic shape that changes slightly every time it moves? These shapes do not apparently conform to a recognisable pattern that we can put a name to. At the simplest level, breasts are vaguely spherical, eyes are oval or almond shaped, arms and legs are cylindrical, and indeed this is what one sees in simple drawings and sculpture, but our basis of recognition is linear — the outline of the eye, not its sphericity.

The second reason is that we do not know what generates the shapes we see. Certainly one can look at diagrams of anatomical structure, but they are very difficult to visualise in three dimensions. If, for example, one looks at a television set from the front, it completely belies its strange overall shape. If we take the back off and look at the tube, its oddly shaped box becomes inevitable and meaningful — we know why the big lump sticks out of the back and why it is so deep. The human body is the same — when you understand the shape of the components you understand the shape of the whole. However, just as you would find it difficult to grasp the shape of a television from the designer's blueprints so it is difficult to understand anatomical diagrams. Unfortunately, we are not privileged to look inside people as we can with television sets. It is the function, therefore, of artists anatomy books to try to bridge this gap by means of explanatory drawings and photographs, but in fact most of these are aimed at two dimensional art rather than sculpture. The sculptor is not interested in the

apparent appearance of objects, the fall of light and shade, only in the actual shape. The objective of this book is to provide this information by direct comparison between the live model, the anatomical explanation of what is seen, and the way it is carved.

Human anatomy is normally referred to by easily forgettable Latin words. These words are very precise and useful to know but since there are many hundreds of them I have generally used everyday English terminology or descriptive words to explain my instructions. In places, the carvings are 'labelled' with the initials of these Latin names. Any artist's anatomy book will show the anatomy correctly named, and I certainly hope that readers will purchase one.

Technically, most of the carving of a figure is very simple if you know what shape to carve. Indeed, most of my courses are anatomy lessons rather than carving lessons. In the projects I have tried to include all the information that is necessary to carve the subject. However, all that information is not necessarily in the part of the book where it is immediately needed. For example, the carving of the male figure does not touch on the head, because that has already been covered in the male head project. Whilst I have cross referenced quite considerably there are many photographs that will show a slightly different view or profile of a particular feature. Furthermore, having said that I have included 'everything necessary', it will be greatly to the reader's advantage to find more information for himself. Collect good photographs of figures, faces, hands, etc.; get hold of good artist's anatomy books and use live models whenever possible.

If the reader regards this book as a course to be followed through, I believe he or she will be successful. There is a strong tendency to dip into instruction books and use the parts that take our fancy, consequently negating a plan that the author has probably spent many weeks, even years, working out. Therefore, I would indulge the reader's patience here and suggest that he/she carves the young male head, then the girl's, following this up with the old man's head and the African girl's, thereby reinforcing the knowledge acquired. Having performed these excercises, he or she should have a sufficient understanding of the subject to carve a human head on a figure — albeit on a smaller scale, the principles are the same. Without doing this — for example, going straight into the book in the figure section — there is little likelihood of an inexperienced carver carving a good head on the body. Certainly, the projects can be altered — the boy does not have to have the band round his head, the girl have long hair, or those particular features; but if you change them you must obviously supply your own reference material for the relevant details. To just try to make them up is hopeless. The accoutrements such as the bow and arrows, metal bits and pieces, can also be changed.

The actual poses used in figure carving are, of course, theoretically infinite, but since ancient times there have been 'classical poses'. For example the figure of The Archer (page 65) is typical and can be traced back to ancient Greece — the weight on one leg, the other bent slightly, tilting the pelvis. The arms are kept fairly close to the body. This stance can be seen all through the history of art to the 20th century. Whilst there are many sculptures widely different to these classic poses, they have a unity and balance which is easily lost when making up your own design to carve. For the purposes of this book I have not strayed very far from the balanced, standing figure. They have the practical advantage of not requiring very large blocks of timber, which figures with more 'movement' in them often do.

The projects for further work include only the working drawings and photos of the finished pieces, and additional figures are shown in various poses. They are all a progression from the main projects rather than something completely different. I believe sufficient information is provided in the book to complete these projects. For future carvings the reader must acquire his own basic reference material; ie. the four main views of the figure for which even Polaroid photographs can be used.

Knowing that some readers will insist on trying to carve a figure from a picture in a magazine or book, I have included a short section on producing

the four views from such a picture; but it is a poor second best. The real point is that, in practice, when you have taken the photographs, made up the drawings, built a clay model and studied the anatomy of a figure that you have conceived, then you understand far more about it before you begin carving than you do with the examples in this book where I have done the work for you. Designing, researching and creating your personal vision is the great pleasure of figure carving.

Tools

THE basic tools of woodcarving in Europe are gouges and chisels (Fig 1). In America, and other countries, special knives and small palm gouges, rather like block cutters, are used extensively. (Fig 2). All these tools cut a flat or curved chip of wood. Much of the work with gouges is done using hand pressure alone, although the first rough work is normally carried out with the assistance of a mallet. The mallet I now use is in fact a stone mason's mallet made from an alloy of lead and zinc. It weighs 2lbs. although the head is only 63mm/2½″ long; it is slightly heavier than my largest lignum vitae heartwood mallet. Its advantages are the conveniently small size to weight ratio and its density. There is very little bounce back when it strikes the gouge, thus it does not waste energy rebounding up through your arm, which is injurious to the joints. The metal does not damage the handles any more than a hardwood mallet, indeed the chisel handles dent the metal.

(This is shown on the bench in Fig 6)

Knives can be very helpful, even to the gouge user, for cutting details and cleaning out deep corners. Their slicing action makes a very clean incision and exerts very little side pressure on the wood.

Rasps and files of various kinds as in Fig 3 are also used almost exclusively by some carvers making simpler forms. They are good for shaping convex forms and many people find it easier to model the wood with a rasp than with gouges. Rifler files, as well as ordinary files, are used to smooth away gouge cuts and refine shapes. Their problem is that they tend to leave deep lines in the wood which are hard to eradicate and seem to re-appear after you think they have been sanded away.

In recent years rotary burrs of many varieties (Fig 4 & 12) have proliferated. These can be divided into the abrasive types and the cutting types. The former are basically a metal shank with a shaped end which is coated with an abrasive substance — diamond, ruby, tungsten carbide grit, etc. They cut well and smoothly, but tend to clog up with wood and are difficult to clean. The cutting type are steel or tungsten carbide and have many small cutting edges. They cut very cleanly when sharp, although the larger ones are prone to jamming in corners, sometimes with dire results, when they kick back. The steel ones, although cheap, blunt very quickly. The burrs are used in various powered hand sets. These range from tiny, low voltage, high speed (20-30,000 r.p.m.) low power drills, through more powerful flexi-shaft units, to machines running on compressed air. Those with flexible shafts are probably most commonly used, although I believe their tendency to kick back is worse.

Generally speaking, the smaller a burr is, the faster it must revolve to work efficiently, consequently most of these machines have speed controls.

There are carvers, particularly in America, who work extensively or entirely with rotary burrs. They work well and cut very cleanly on hard woods such as boxwood, ebony, rosewood, etc., and, of course, ivory and bone carvers rely on them heavily. The cutters are available in a very wide range of shapes and sizes, and whilst one may not use them generally, there are certainly occasions when they solve a problem perfectly.

Finally, we need measuring instruments (Fig 5)

Figure 1 Gouges: For most figure carving a range of curves and sizes is required. The selection illustrated would make an excellent starting set. From left to right they are No.9 — 12mm, 8mm, 4mm; No.7 — 12mm, 8mm, 4mm; No.3 — 12mm, 8mm, 4mm; No.11 — 2mm; No.12 — 4mm; No.1 knife. It must be remembered that English carving chisels have a slightly different numbering system to the European ones illustrated here, therefore tools should be selected by the actual size and shape.

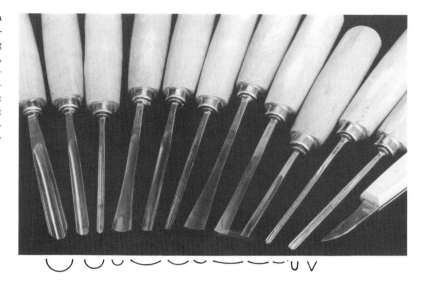

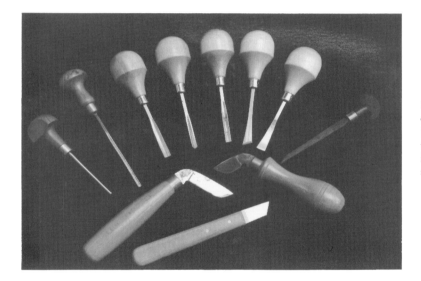

Figure 2 In North America, the European type of carving gouge is less common, palm gouges (block cutters) are used extensively as well as a wide variety of specially shaped knives. This illustration shows a range of palm gouges and a sample of knives used in carving.

Figure 3 Files and rasps: A wide variety of files and rasps are available — these are merely the ones I use. From left to right they are a round Surform, a traditional half round rasp, three different shapes of rifler file, a diamond coated needle file, an ordinary needle file, a round file and a half round file. Rifler files which are cut like normal files are different to riflers which have hooked teeth like a rasp and tend to tear the wood. There is a vast range of rifler files available but they have very limited use.

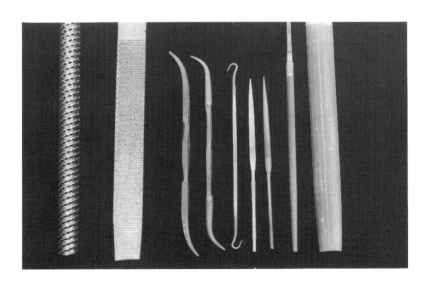

ranging from tape measures to micrometers. All can be useful at times, but most of our calculations will be of relative sizes, eg. checking that one feature is the same size as another or transferring measurement from the drawing to the wood.

Basically we need dividers, outside and, possibly, inside callipers and a tape measure or ruler. Different sizes will be helpful to cope with large and small measurements. A profile gauge is also extremely valuable.

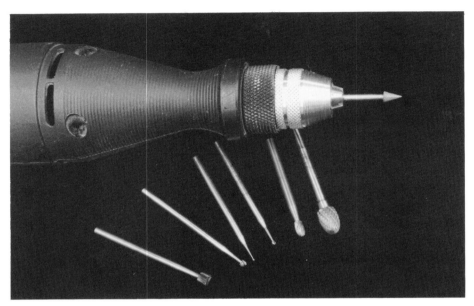

Figure 4 Rotary burrs and handset: This is a typical economically priced low voltage electric drill running at 16,000 r.p.m, with a three jaw chuck, which is preferable to the collet type. A variety of common burrs are shown from a 6mm tungsten carbide burr to a ½mm dental drill.

Figure 5 Measuring instruments: These can cost a great deal of money but high quality engineers' tools are not necessary for our purpose. From left to right are a profile gauge, a vernier gauge, dividers, outside callipers and a vernier gauge adapted for measuring two dimensional drawings onto curved surfaces and below is an ordinary engineer's square.

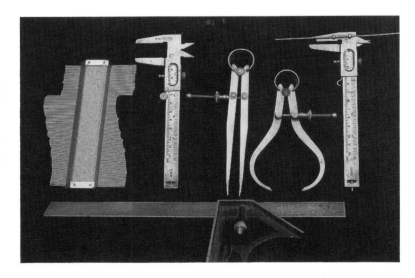

Holding Devices

HOLDING the workpiece is one of the single most important factors in successful carving. There are many ways of doing it, from the Balinese method of sitting on the floor and using your feet, to the sophisticated and very expensive, powerful, hydraulic clamps operated by compressed air. Even with the best clamps there is still the problem of holding the workpiece to the clamp. Limewood end grain, for example, is very poor at holding screw threads and even the largest screws tend to rip out if there is excessive leverage on them.

A large woodworking vice might be considered a basic piece of workshop equipment, but they are usually placed rather low down for carving, they are completely fixed as regards height and the wood has a tendency to suddenly slip, not to mention the fact that they are very expensive.

Large engineering vices are cheaper, have a more powerful grip in their smaller jaws, and can be easily fixed at a higher position because they are mounted on top of the bench.

The traditional woodcarver's chops, somewhat like an engineering vice in principle, are still available. They are used quite satisfactorily by some carvers, but again are quite expensive.

The carver's screw is very simple and limited in itself, but by adapting it to wooden jigs and

sometimes using two, it can become very versatile at low cost.

Portable workbenches of various types are available, but by their portable nature they are too light, and, whilst like most things, some people manage, I would not recommend them.

Custom-made clamps for woodcarving shown in Fig 6 are now becoming more available. The cheaper ones will be found to be fine for small work, but are not sufficiently robust for the leverage exerted by working on a tall figure, which, after all, is what we are trying to carve. However, a good clamp which could cope with all but the largest work (certainly all the pieces in this book) opens up a whole new attitude to carving, enabling work to be done which would be almost impossible without one. Whilst these devices are expensive, they would compare very favourably, price-wise, with other tools, such as a circular saw for a cabinetmaker for example, and occupy the same position of importance.

Most clamps consist of a large steel ball and face-plate, to which the wood is fixed, which can be tilted and rotated in any direction, then locked in place. It must of course be held firmly in place on a solid bench.

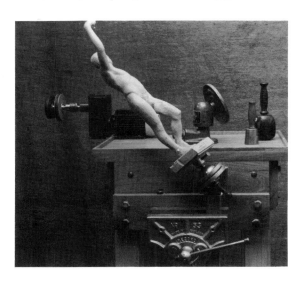

Figure 6 This is a sturdy woodcarving bench made of heavy timber, bolted together, about 1.10 metre/43¼″ high. Weights can be put into the base to ensure maximum stability. On the front is a woodworking vice and the polishing machine is fixed to the top for convenience. The clamp in the vice consists of a steel ball which is locked in position between two metal rings, pulled together, by the threaded handle. A face-plate is located on the neck of the ball to which the wood is screwed. In addition to the range of movement of the ball, the square bar to which it is attached can be raised, lowered and tilted in the vice, creating a wide variety of positions. On top of the bench is a hydraulic clamp which has a versatile range of movement but must be bolted down so it cannot be raised or lowered. Also the leverage it will withstand without moving is very limited, whereas the mechanical one can be tightened almost indefinitely and can be used for much larger carvings. Also shown are two mallets — a traditional lignum vitae woodcarver's mallet and a metal stone mason's mallet, which I prefer.

Sharpening

IN the last ten years a plethora of powered sharpening devices have appeared on the market. I would not pretend to have used or even seen them all. They can be divided into wet grinders, dry grinders and polishing wheels. Traditionally, cutting edges were ground to shape on a wet grinding wheel, then sharpened on a fine stone (Fig 7) and finally brought to a perfect edge using a leather strop dressed with a fine abrasive powder. The old wet grindstone is now superseded by sophisticated varieties of powered whetstone which are very safe to use, both for the user and the tool. They run slowly and are very controlled and present no chance of overheating the metal. Different grades of stone will produce quite fine edges which can then be stropped.

The dry grinders, like the motorised bench grinder are more tricky to use but much quicker. I use a dry grinder (Fig 8) which employs aluminium oxide belts at high speed and, if used correctly, with good new belts, does not burn the tools. I can re-grind and strop a badly chipped gouge and be back working with it in less than a minute.

Sharpening on a sanding disc is shown in Fig 9.

Most of the methods of stropping employ a wheel made of hard felt (Fig 10) or leather as a carrier for a metal polishing compound. This removes the scratches of the grinder and leaves the tool ready for use. Many of the wheels being sold are too soft and round off the bevel.

In the final analysis the reader must study the latest information on these machines in magazines, exhibitions and so on, and decide what is best for their purposes and what is affordable, but I do believe that they are a better option than the traditional oilstone which requires a great deal of skill and is very time consuming.

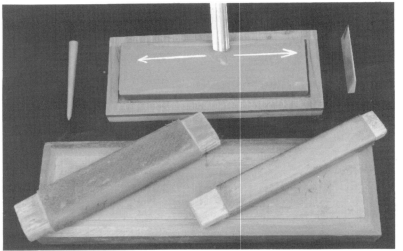

Figure 7 Oilstones — The traditional method of sharpening gouges is an oilstone, usually an Arkansas, and is slow and difficult. Although one is supposed to move the tool in a figure-of-eight pattern on the stone, simply moving it back and forth is easier. The gouge must be held at a constant angle of about 20° and rolled from side to side to sharpen the whole bevel. When a burr has been raised on the edge this is removed by sliding a suitably shaped slip stone back and forth along the inner curve. The tool is then burnished on the leather strop until the bevel is mirror bright. Regular stropping will keep the gouge sharp for some time. 'V' tools are sharpened by rubbing the two sides on the oilstone, but the point of the 'V' must be rolled as if it were a very small gouge. Great care must be taken to keep the two sides even and to avoid producing a hook at the point of the 'V' where the metal is thicker. A 'V' shaped slipstone will be required to remove the burr on the inside. Flat chisels are simply laid flat on the stone and worked up and down like a carpenter's chisel, but with a bevel on both sides.

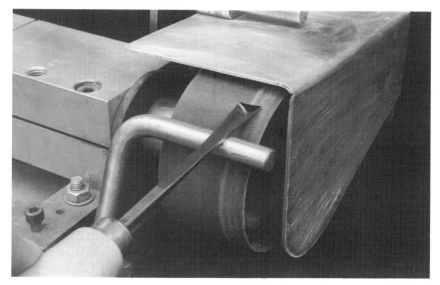

Figure 9 Figure 9, below, shows a gouge being sharpened on a sanding disc. There are various clamps on the market which will hold an electric drill vertically. A disc sander is fitted in the drill and the tool simply laid on the sanding surface and moved appropriately to produce a bevel. Velcro backed discs are ideal since they can be changed very easily. The basic grinding is done with a medium grit, the honing with a very fine grit and the stropping with a piece of dressed leather glued to a sanding disc.

The arrow shows direction of rotation. Obviously it would be dangerous to apply the tool against the direction of rotation so that side of the disc is covered by a piece of board. This method is cheap, easy and adequate, provided clean, new discs are used and care is taken not to burn the metal. If the chisel is frequently dipped in cold water, this should be avoided.

Figure 10 Polishing machine: Mechanical stropping, used to produce a fine edge on a gouge, is carried out on a hard felt wheel. This acts as a vehicle to carry a metal polishing abrasive paste. The wheel on the left is not really hard enough and is beginning to spread and loose its shape. Whilst it is adequate, the tool will press into the felt and will round off the bevel which will press into it. The wheel on the right is much harder and does not compress or distort and will therefore will maintain a flat or even a hollow bevel. Wheels made up of layers of cloth are of no use at all. Hard leather wheels work well but quite quickly become pulverised by the tool and loose their shape.

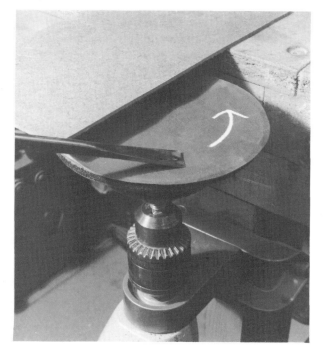

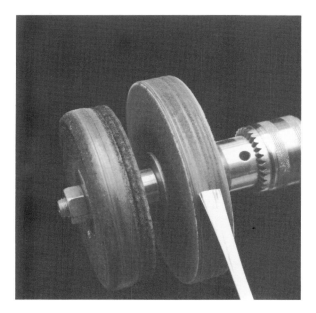

17

Timber

DESPITE the vast range of wood now available from innumerable retailers, it is still difficult to get good dry wood of sufficient size for woodcarving. The normal maximum thickness supplied by merchants is 100mm/4″ and this is only sufficient for the smallest carvings unless they are specifically designed for it (quite a large carving can be carved if the arms are jointed on). Laminating two or more thicknesses is difficult to do successfully and obviously results in glue lines in the finished piece. Over the years I have used many different timbers and whilst they are interesting to work, I have eventually come to rely mainly on walnut and limewood.

Limewood is occasionally available in sizes of 150 and 200mm/6 and 8 inches thick. It dries quickly with minimal cracking and even if not completely seasoned, with care, it can be used successfully. It is easy to carve and although ideal for beginners, has been used for some of the world's finest carving.

Walnut is expensive, but it has beautiful colour and grain which, unlike many timbers, does not obscure and confuse the forms. Although much harder than limewood, it carves beautifully and takes fine detail. Because of its grain and colour, it is excellent for concealing the glue lines of laminating and I do this frequently. I suggest that the reader begins by using limewood, progresses to walnut and then tries other timbers such as oak, sycamore, elm, etc., as availability and inclination dictate.

In North America the most commonly used timbers are basswood, the equivalent of European limewood; walnut, which is similar to European walnut, and butternut. Tupelo gum is also widely used in the southern states.

Working Green Timber

The alternative to the problems of size and availability of some timbers is to use 'green' wood — that is unseasoned wood, straight from the freshly felled tree. Virtually any size of timber can be obtained in this state at a fraction of the cost of the dry seasoned product (which is rarely available in large sizes).

What is the process of using such wood? If you leave it as a block drying out for more than a few days it will crack. It must be kept in a polythene bag, in which condition it will remain stable for a considerable time, although it may rot eventually.

If you use the wood quickly, bandsawing a figure from it, most of the block will be gone and the largest part of the figure will only be a few centimetres thick, giving little trouble. However, something like a large head, when the block retains much of its bulk, I would not recommend.

Assuming we have bandsawn a figure, rough it out as quickly as possible to reduce the wood, keeping it in a polythene bag at all times except when work is in progress. When the carved work is finished, it will be found difficult to sand because of the wetness. The wood must now be left to dry, on the surface at least, so the bag must be removed for perhaps an hour a day for one week, then permanently for a couple of weeks but in a cool, unheated atmosphere. At the slightest sign of cracking, replace the bag.

After a couple of weeks exposure the carving should be dry enough to finish normally, but do not use cellulose sealer as any dampness will make it go white. If you can not wait until the figure is really dry, say three months, then finish it with oil,

repolishing at a later date. Keep the carving in an unheated area, out of the sun, for at least six months.

In this book, the Archer, the Jazz Dancer, the African girl and the Warrior were all carved from 'green' timber.

Most timber will be found to have features and defects such as knots, dead knots, sap pockets, ingrown bark and cracks. Although some of these may be so serious as to render the piece of wood unusable, this is rarely so and these faults must be accepted as being in the nature of the material. Usually, one is able to conceal them in some way if required. Holes and cracks can be filled with coloured resins or other proprietary fillers, or with pieces of suitably matching wood, as in the case of the Jazz Dancer Fig 225c.

Table 1 below is a list of carvable timbers.

SPECIES	WORKABILITY	REMARKS
Apple	Fairly hard but carves well, good for detail.	Cracks badly in drying so usually only small sections available.
Basswood	Light, soft wood, very easy to carve.	Probably the most popular American wood for carving.
Beech	Fairly hard, but carves well, taking good detail.	Although readily available it is rarely used for carving.
Birch	Fairly hard, carves cleanly and takes good detail.	Rarely used except in Scandinavia where excellent work has been done.
Boxwood	Very hard, fine grain, excellent for fine detail.	Available only in small size logs.
Butternut	Easy to carve, good for large scale work.	Widely used for carving in America.
Cherry	Fairly hard, excellent carving qualities, good for detail.	Readily available in quite large sections.
Chestnut, Sweet	Similar carving qualities to oak but easier to work.	Widely used for carving in the past, large sections available.
Elm	Fairly hard, coarse texture, difficult grain.	Widely used for very large scale work.
Holly	Hard, fine grain, excellent for detail.	Mostly small sections, although large pieces can occasionally be found.
Huon Pine	Soft wood, very easy and good to carve.	Very popular in Australia, but has become difficult to obtain.
Jarrah	Very tough wood, difficult to carve.	Popular in Western Australia, but becoming scarce.
Jelutung	Very soft, light, easy to carve wood.	Readily available, used extensively, but its total lack of colour or grain pattern makes it an unappealing timber.
Lebanon Cedar	Soft, light, easy to cut, but will not take detail.	Available in very large sections, best used for large carvings.
Laburnum	Very hard, cuts cleanly and takes good detail.	Normally in small logs, cracks badly in drying.
Lime	Soft, light wood, very easy to carve, good for detail or large pieces.	Certainly the most widely carved wood in Europe. Popular in America (Linden). Dries quickly and well, large sections available.
Kauri	Soft wood, carves quite well; not good for detail.	Very popular in New Zealand, becoming very scarce.
Mahogany	Carves well, grain can be difficult. Not good for fine detail.	Because of the many species offered as mahogany only the best should be used, ie. Brazilian, Honduras.
Maple	Very hard, fine grain, difficult to work but takes fine detail.	Its rather uninteresting character makes it hardly worth the effort.
Oak (European)	Hard, heavy, coarse grained, good for larger pieces.	Extensively used for carving for centuries, less so today.
Olivewood	Heavy, fine grained, carves beautifully.	Difficult to obtain in large sections because it splits so badly.
Pear	Fairly hard, fine grain, excellent for fine work.	Becoming difficult to obtain in large sections.
Sycamore	Hard, fine grain, not easy to work.	Large sections are available but it's hard work.
Teak	Heavy, oily wood, good for large scale work.	Becoming difficult to obtain large pieces.
White Beech (Australian)	Fairly hard, easy to carve.	Popular for carving in Eastern Australia.
Totara	Fairly hard, cuts easily and cleanly	Extensively used by Maori carvers in New Zealand.
Walnut, American	Fairly hard, carves beautifully for all types of work.	Very popular in America, available in large sections.
Walnut, European	Fairly hard, carves very well, slightly more difficult than American walnut.	Very popular for carving, available in large sections.
Yellow Pine	Light softwood, cuts cleanly, but not very strong.	Very unpredictable timber, but worth the effort. Large pieces can be obtained.
Tropical Hardwoods, eg. Rosewood, Ebony, Zebrano, Blackwood, Ironwood, etc.	Most are extremely difficult to work.	Usually small sections, used only for special purpose. In conservation terms one should be looking to use more freely available timbers from sustainable sources.

Finishing

THERE are two main ways of finishing the carving — sanding and tooling. When either of these methods have been completed, the usual procedure is to apply some kind of polish or sealant to protect and enhance the surface of the wood.

A tooled finish is an attractive option to many carvers for a variety of reasons. Many believe it is the 'traditional' method — this is simply not true; that it is somehow the 'right thing' to do, which is purely a subjective judgement; or that it is easier, which is a fallacy. The only valid reason for a tooled finish rather than a sanded one, is that the sculpture will be improved by it. On the scale that most readers will be working, this will rarely be the case. There may be times when a difference in *texture* may be required, such as is the case of the dancer's trousers, Fig 208a & b, but the real tooled finish that most people are thinking of only really works on large scale, chunky pieces of work, such as those of Ernst Barlach.

Tooling basically involves covering the entire surface of the carving with clean chisel and gouge cuts. Obviously large convex surfaces are very easy to do, but to achieve a good, homogenous pattern of facets in the folds, hollows and details of even a quite large figure, say about 1 metre/40″ high, requires a wide range of very sharp gouges, considerable skill and great patience. In principle, it is simplicity itself, in practice, just as long and tedious as sanding. The alternative is to create a perfectly smooth surface, free of cuts and scratches over the whole surface of the wood. The first stage in achieving this, or for that matter, a tooled finish is to leave the figure tidily and neatly carved, clean cut in the corners and without the deep marks left by stabbing gouges or knives into the wood, that are almost impossible to remove. Assuming that the carving is in this condition, the process is simply to smooth the surface using abrasive materials, working from coarse through to fine. There are a huge variety of these, from the cheapest glass paper to the most sophisticated resin bonded aluminium oxide cloth.

Personally, I use garnet paper for the majority of the work because the grit does not flake off when it is creased. Better quality grits, like aluminium oxide, will certainly remove wood much faster, especially harder woods, and these should be employed wherever possible. However, those large areas requiring much material to be removed are not really the problem. The real difficulties are in sanding the fine details, the tight corners and deep hollows. Let us take an eye, for example, as shown in Fig 65. First, the eyeball must be made smooth, in the sharp edges under the lids and the tight deep crevices at the corners. Then the sharp creases above the lid, the shallower rounded fold below the bottom lid and the deep rounded hollow between the eye and nose.

This would be achieved by using simple garnet paper, adapted in various ways, Fig 11, and possibly one or two power tools Fig 12. The ball would be smoothed using paper folded to a point as seen in Fig 11c, the sharpest point Fig 11d being used for the deepest corner. The edges of the lids and the crease above the top lid can be done with a single sharp fold Fig 11b, whilst the shallow fold below the eye is done with the rounded edge of the rolled paper in Fig 11e. The deep hollow next to the nose can be cleaned up with the same rolled cone, but since it is not carved too cleanly power tools make it easier. The carving can be cleaned up with

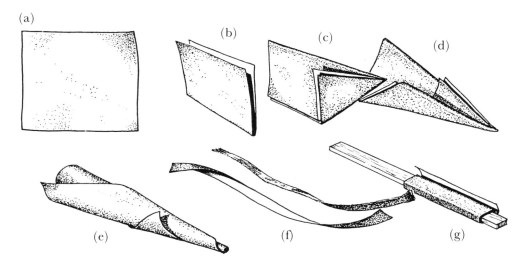

Figure 11 Sanding: (a) garnet paper 50mm × 50mm/2″ × 2″; (b) folded to make a sharp edge; (c) folded to make a point; (d) folded again to make a sharper point; (e) rolled to make a cylinder or cone; (f) strips of garnet paper or abrasive cloth; (g) wrapped or glued around shaped sticks.

a burr Fig 12b or Fig 12c, then smoothed with a diamond burr Fig 12a or the thumb shaped sander Fig 12f. These are available in different sizes and grades.

The garnet paper is best cut into 50mm/2″ squares, and must be constantly refolded to maintain the sharp edged creases. Do not try to economise on it — you will actually use very little, although it may look like lots of pieces.

Some of this work can be helped by using files, rasps and rifler files, Fig 3, but these tend to leave their own score marks in the wood, which are almost as difficult to remove as the gouge cuts. I regard these more as shaping rather than finishing tools.

Work the entire carving through all the grades of paper, making sure that the toolcuts are completely eliminated by the first sanding, the scratches from the coarse grade eliminated by the subsequent one, and so on. If you do not, the slight undulations of the toolcuts and the coarser scratches will persist, only to reveal themselves when the wood is polished. I cannot emphasise this point enough and it is to ensure that they are removed, that I recommend wetting the wood with hot water between each grade of sandpaper. This raises the crushed fibres and reveals the areas not sufficiently worked on.

The motorised abrasive tools Fig 12 have very limited use, but are invaluable in the right places. Experience will show you when. Similarly, the practice of wrapping paper around shaped pieces of wood Fig 11g is extremely valuable at times.

The grades I usually use are as follows:-

 80 grit for removing toolcuts on large areas.
 120 grit for removing toolcuts on more detailed areas.
 150 grit for the real smoothing and some very subtle shaping.
 180 grit as a final smoothing.
 240 grit to rub down the first coat of sealer.
 400 grit to rub down the second coat of sealer.
0000 steel wool to rub down the second coat of sealer, if there is not to be a third coat.

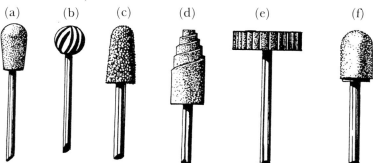

Figure 12 Powered finishing tools: (a) diamond burr; (b) cutting burr; (c) tungsten carbide grit; (d) roll of abrasive cloth; (e) miniature flap wheel; (f) preformed sanding head.

21

This is the only time I use steel wool. Using it on bare wood can be disastrous, especially light coloured species such as lime; the wire gets into the fibres and make a dirty mark which is almost impossible to remove. The nylon scouring pads that are available are somewhat better, but not a lot.

Finally, scraping, using pieces of steel, knives or whatever, I use occasionally. Some people employ this method almost exclusively to good effect, but once again, I find it effective on areas which are not difficult anyway. The tricky bits always seem to come down to elbow grease and persistence, which leads on to my final point on sanding, that is, pacing yourself. I estimate that my average carving takes twenty one days, five or six of which are sanding. If I spend an eight-hour day sanding, my fingers are so sore that I can barely hold the paper. If I persist the next day, the skin may well split and start to bleed. It will then be about three days before I can resume sanding. Using rubber gloves is often recommended. They take a little getting used to, rather like wearing a dust mask, but they are effective when using the coarse grades for rough sanding. However, the loss of sensitivity when working on the finer detail is too great to justify their use.

The best way to avoid the sore fingers is to spread out the sanding. This I do by sanding an area as the final carving of a particular part is completed (eg. when the carving on the head of a figure is finished completely I sand it) then continue the final carving on an arm or the back and so on. To me, this has the added advantage that you are able to see the finished effect on the individual sections and alter them as you go, rather than having to wait until the very last stage.

As stated above, I sand the carving to 180 grit and then apply a sealer. This is an ordinary commercial clear cellulose sanding sealer available in many good hardware shops. In the past I used brown shellac sanding sealer, but any coloured sealer, by its nature, puts a layer of colour on the wood. When this is rubbed down, whether with steel wool or sandpaper, it becomes patchy, and those areas that are worn through to the wood are back to the original colour, whilst in the deeper

corners and hollows, the brown colouring remains. This two tone effect is almost impossible to rectify, since another coat of sealer merely darkens the whole evenly, thereby retaining the two tone effect. Therefore, the sealer must be clear to be safe.

When the sealer is rubbed down with 240 grit the wood should feel silky smooth. Look carefully for the blemishes — toolmarks, scratches, cuts, etc — and remove them. Dust off thoroughly and apply the second coat of sealer. Sand down with 400 grit — or steel wool — and wax polish using a good quality furniture wax, being careful not to let it accumulate and dry hard in the details. I use a toothbrush to apply it and a soft polishing brush or large paint brush to buff it up. Finish with a cloth.

Let it be said that I know little of modern finishes, lacquers, etc., which is a highly specialised subject and about which excellent books have been written. I suggest that those readers with special requirements study them.

The only other finishes I have used are matt polyeurethane, greatly diluted, which was satisfactory; oil, which leaves the wood completely dull and attracts dust; and a canned cellulose spray which I feel is worthy of more investigation. However, the sealer and wax have served me, and many other carvers, well, many times; it is easy to do, easy to maintain, and improves with repetition.

When the polishing is complete the figure needs to be displayed in some way. (If the figure is to be cut off the waste block then the polishing is done whilst still attached and the cut area sanded and polished after separation.) This should have been decided at the start; however, the usual thing is either another block of wood or a piece of stone such as marble or one on the other. Occasionally one will see something more exotic such as a crystal formation, a root, a shell, a slab of raw stone and so on.

It is a subjective decision, but should be a decision, not an afterthought forced by necessity or convenience. Whatever is used, the area of contact should be perfectly formed — if feet, then they should be properly flattened, then the soles modelled.

The figure must be attached to the base with

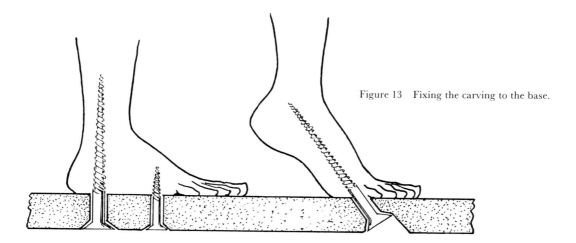

Figure 13 Fixing the carving to the base.

some kind of metal rod. This may be a screw passing through the base into the foot, or a metal dowel fixed into a hole drilled in the base. Either way, careful drilling will be necessary into the foot, usually through the heel and up into the leg, although more difficult arrangements may be needed if the heel is raised. The metal bar should be glued with epoxy resin. (Fig 13).

Decoration with Metal etc.

The embellishment of wood sculptures with stain, paint, gold leaf, metal and precious stones is not new, indeed most medieval statuary was originally so treated, although it is not to everyone's taste. Personally I feel that it greatly enlivens and enriches suitable pieces, and, more importantly I get great pleasure from doing it. Working copper and silver (I hesitate to use large pieces of gold, although I do use wire and beads) is very interesting and satisfying, and it is not difficult or expensive. Similarly, semi-precious stones are readily available from suppliers in a dazzling variety of types, shapes and sizes at astonishingly low prices. Most of these stones can be shaped and polished with readily available equipment such as diamond burrs and metal polishing compounds.

CHAPTER SEVEN

The Male Head

THE head is the focal point of the body. It is the one part that gives meaning to the rest, endowing it with expression, direction, intention — all the subtle innuendoes and nuances that might possibly be expressed by a combination of hands, arms, legs, etc. but only very ambiguously. The ballet dancer Margot Fonteyn's greatest asset was the expressiveness of her face and one only has to compare the anonymity of a headless Greek statue with the power and arrogance of a disembodied Egyptian portrait.

It follows that unless we can put a meaningful head on a figure carving we have only really achieved an anatomical study — not a really individual person. True, some of the idealized figures from the past had faces that were almost clones rather than real people, but their youthful beauty and sightless gaze seems to have acquired a divine life of its own.

Figs 14 and 15 show examples of expressive faces on figure studies.

The Male Head

The male head that I have chosen as the basic model is a fifteen year old boy, lacking in the lines and creases of an older person, but past the stage of childishness. (Fig 16). The bone structure is not hidden by fat or loose skin enabling a direct comparison with the anatomical illustrations.

It must be stressed that in this carving we are not attempting a portrait or trying to create an individual likeness. The object is to produce a realistic head of a particular type with the features in the right places and the basic bone structure and

surface anatomy acceptably accurate. If this can be achieved we have made a major step forward, which will be built on with the second, female, head.

Figure 14 Head of a warrior from the figure in the projects section, p.142. This head is approximately 70mm/2¾″ high and illustrates the level of detail and expression one might expect to achieve on this scale. As you can see there is little difference between this and the large scale head Fig 16.

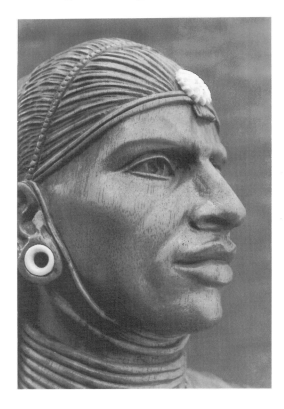

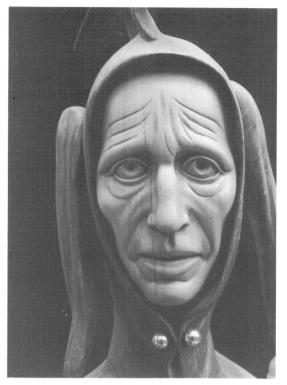

Figure 15 Face for figure of a jester carved in pear and set into a walnut hood. This is approximately 80mm/3⅛″ high and shows a stylized and exaggerated expression used on a caricature.

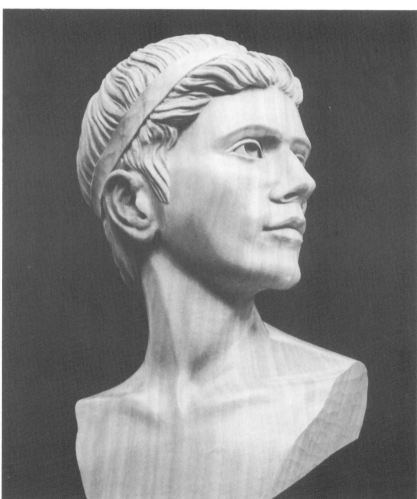

Figure 16 The male head.

The first step in attempting such a portrait, having decided the pose, is to photograph the model. When the head is turned it is still preferable to take the basic pictures full face and profile. This will require a slightly larger piece of timber, but the prospect of working from a three quarter view is not a viable one — the whole process is fraught with complications.

The front view must be taken from a position exactly central to the face — ie. level with the nose, and precisely equal amounts of ear showing on either side Fig 17 & 21b. The slightest deviation from this will be magnified many times when the drawings are enlarged and cause serious discrepancies. Similarly the side view must be taken from the same level and show precisely one side of the face. The back view is really only for information about the hair and muscles of the neck and shoulder. Both profiles should be photographed because the face may not be perfectly the same on both sides and because the position of the head in relation to the shoulders may be different, as in this case. The shoulders will be distorted because of the camera's angle of view. The further away the camera is (using a long lens) the more accurate the picture will be.

When the four main photographs have been satisfactorily produced they need to be enlarged to the size of the proposed carving. This can be done photographically, which may be expensive, because the head must be identical in size on the enlarged pictures, and as the images on the negatives probably are not, considerable work on the

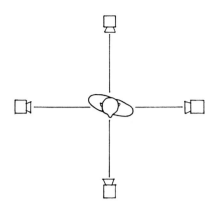

Figure 17 Photographing the figure

enlargement would be needed. It would, however, be ideal to have the photographs. Failing this, and the method I always use, is the photocopier. Most commercial photocopiers have an enlarging and reducing facility of great accuracy, on which the degree of enlargement required can be mathematically worked out and programmed in. By taking precise measurements of salient features of the face such as the underside of the chin to the top of the eyebrow, the requisite percentage increase of each view can be assessed and fed into the photocopier. Check these measurements again on the enlarged pictures.

The photocopies should now be arranged in a row on the drawing board with tee square, and lined up so that the features on the front and side views are exactly level. Discrepancies may be found: these could be caused by change of camera height or angle, movement of the model such as

Figure 18 & 19 Fig 18 shows a figure being photographed from close to with a standard lens. On the photograph, the raised hand will appear not only very enlarged, but well above the head, although it is in fact level with it. The picture will show a view of the upper side of the feet.

In Fig 19, using a longer lens from further away, although the hand will still be slightly above the head, it will not be nearly as bad as in Fig 18. Similarly, the feet will appear more from a front view than an upper one. Obviously these distortions cannot be completely eliminated, but they can be reduced to a level whereby comparison of the views will resolve the situation.

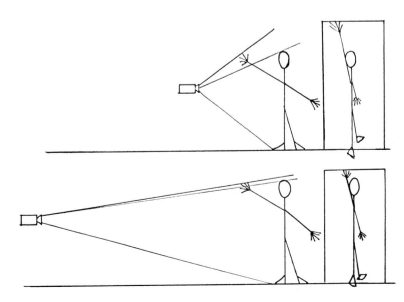

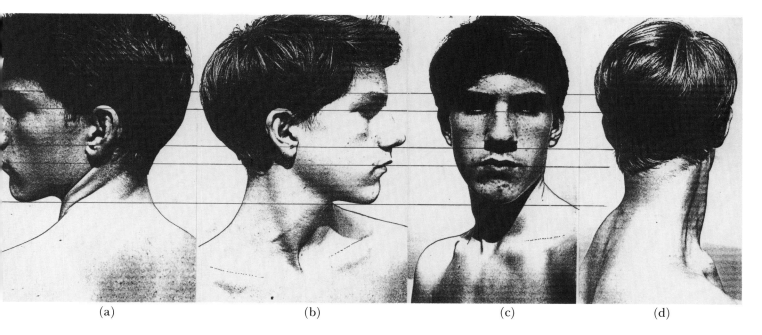

(a) (b) (c) (d)

Figure 20 The process of making drawings.
Having obtained the four basic photographs,
Figure 21, these must now be made as nearly
equal in size as possible. A careful measurement
is taken, in this case from the bottom of the chin
to the eyebrow, and the photographs are
enlarged on a photocopier until this measure-
ment is the same on the three views where the
features can be seen. Other important features,
such as the nose and lips, also line up. However,
it will be seen that many other features can not
be reconciled — the top of the head, the ears,
the shoulder — and that the rear view is of little
use other than as reference material. One view
must be selected as most suitable for the basis of

the drawing, in this case the side profile (view
b), and all other views altered to fit this one.
The full face view lines up reasonably well but
the ear must be dropped slightly and extended
outwards to allow for perspective. The hollow at
the top of the breast bone must also be lowered
to match, and considerable tolerance allowed
for the shoulders, since perspective distortion
over the width of them will be considerable.
With care, accurate drawing can be arrived at,
but an allowance of wood in the bandsawing
must be made in doubtful areas. This also
clearly shows the inaccuracy of photographs,
which must always be guarded against.

tilting of the head or distortion caused by the
camera being too close to the model. These can
usually be adjusted quite easily, using the profile as
the truer image, because it is flatter. Much greater
discrepancy will be found in the shoulders which
are likely to exhibit all the aforementioned faults to
an exaggerated degree. The front view of the
shoulder should be taken as a basis to work on. The
levels of the collar bones can be taken as correct
from the front, but not from the side. Thus it will
be seen in my drawings, Fig 22, that the front view
(of shoulders, profile of head) is drawn complete
but the side view (front of the head) is left as a

block to be worked out in the process of carving.
The back view is useful only for anatomical
information.

Having worked on the photocopies, aligned all
the features on the face and made appropriate
allowances for the shoulders we should then make
any aesthetic alterations we see fit . I have changed
just the hair in keeping with my original concept of
a Greek athlete. A tracing can now be made of the
exact outline of the amended photocopy images.
These tracings are the 'Masters' for bandsawing the
wood. Make sure they are accurate and complete
— it is easy to miss out a detail of the outline.

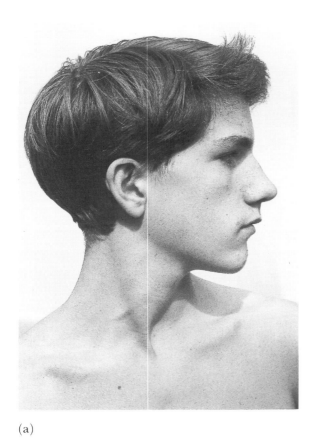

(a)

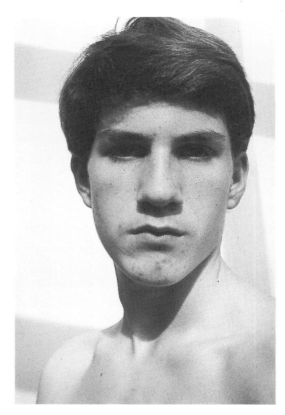

(b)

(c) (d)

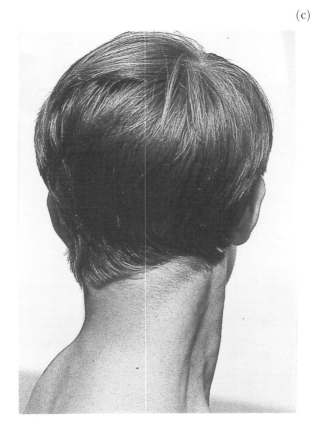

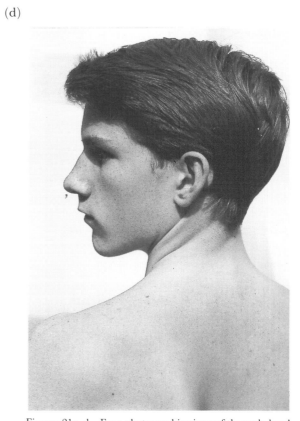

Figures 21a–d Four photographic views of the male head.

28

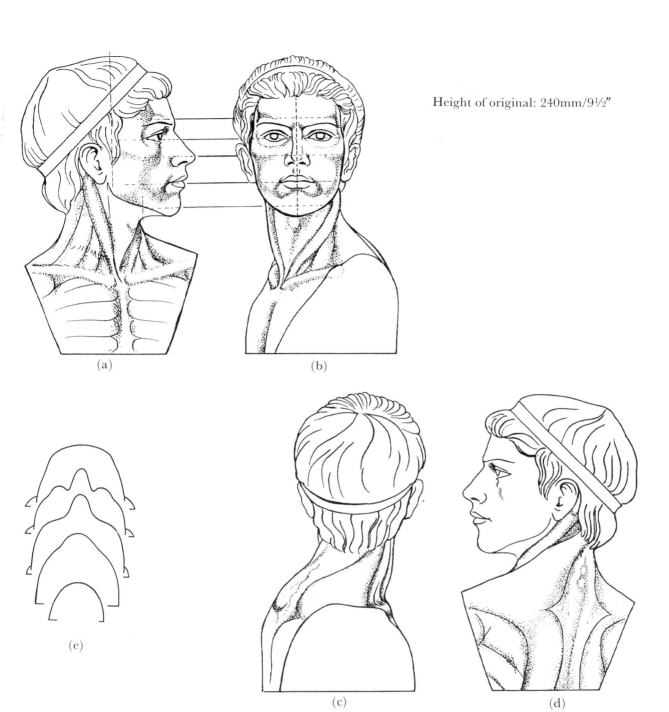

Height of original: 240mm/9½″

(a)

(b)

(e)

(c)

(d)

Figures 22a–e These are the master drawings for the head and can be enlarged on a photocopier to the required size. Only the actual outline of the front and side views, a & b, need to be traced onto the adjacent sides of the wood (Fig. 28). The dotted lines on Fig. 22a & b are the levels of the cross sections Fig. 22e and the depths to which they reach. Fig. 22b shows the centre line from which measurement should be taken for the front view.

The shaded area shows some of the prominent forms. The edge of the frontal bone can be seen running up the forehead on Fig. 22a & b. The eye socket is indicated — notice how far back it reaches on Fig. 22a. Below the eye the cheekbone drops almost vertically and turns back towards the ear. Below the cheekbone the cheek hollows to form a puffy area

at the side of the mouth and again where the large jaw muscle can be seen nearer the ear.

On the neck, the windpipe twists around from the centre of the lower jaw to the centre of the chest (Fig. 39 & 40). On either side of it the strap-like sterno mastoid muscle runs from behind each ear to the inner ends of the collar bone — the nearside one in Fig. 22a is clearly discernible in the photo Fig. 21a, the far one, twisting round the neck, less distinctly.

On the back the upper vertebrae are just discernible as slight bumps and the shoulder muscles twist up and round the back of the neck (compare with anatomical drawings Fig. 133a). The corners of the shoulder blades stand out quite clearly.

29

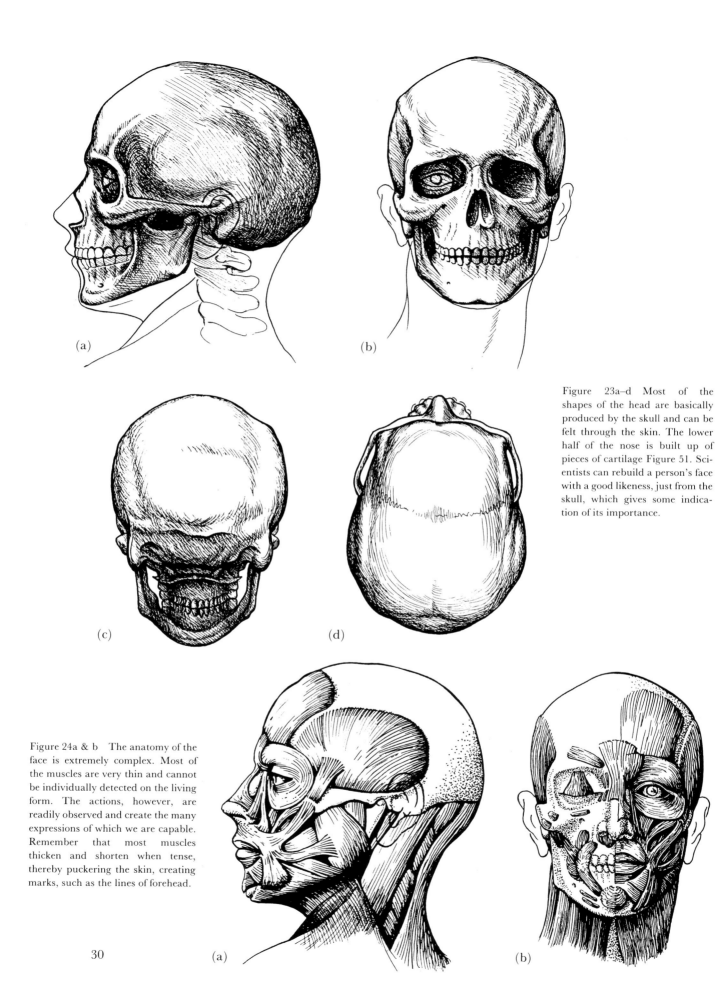

Figure 23a–d Most of the shapes of the head are basically produced by the skull and can be felt through the skin. The lower half of the nose is built up of pieces of cartilage Figure 51. Scientists can rebuild a person's face with a good likeness, just from the skull, which gives some indication of its importance.

(a)

(b)

(c)

(d)

Figure 24a & b The anatomy of the face is extremely complex. Most of the muscles are very thin and cannot be individually detected on the living form. The actions, however, are readily observed and create the many expressions of which we are capable. Remember that most muscles thicken and shorten when tense, thereby puckering the skin, creating marks, such as the lines of forehead.

30

(a)

(b)

Bandsawing

The problems of bandsawing tend to be underestimated. They fall into two main categories — spoiling your piece of wood and spoiling your fingers. In my experience they are usually caused by the same faults — blunt blades and incorrect manoeuvering of the wood.

The steps I work through are as follows:

Select a piece of wood which allows at least 6mm/¼″ to spare outside the outline of the carving. Plane the wood perfectly square — if you do not the blade will cut at different angles, the cuts will not meet and waste pieces will not fall away. Also the blade is liable to be outside of the wood at the bottom of the block when it appears to be inside the cutting line (Fig 25b). This could result in terrible injury to the hands which are holding the block at exactly the point where the blade came out.

Fit a really sharp blade to your bandsaw. I use a hardened steel, six teeth per inch (6tpi), skip tooth. This will cut a curve of about 15mm/⅝″ diameter in very thick timber. Blunt blades will wander all over the place, and worse still cause barrelling, Fig 25a. This is when the blade curves inside the block, causing inaccuracy and, again, with the possibility of the blade coming out through the side of the block and cutting the operator. Furthermore, blunt blades require greater pressure to push the wood through them and forcing machines is always dangerous.

Ensure that the blade is perfectly square to the bed and check this by cutting a spare piece of wood and reversing it to see if the cut matches up to the blade.

Check that all guards are in place and guides are operating correctly according to the manufacturer's instructions.

Now take the block of wood and square a line round it near one end. Place the bottom line of one tracing on this square line, placing the drawing as centrally in the block as possible. Tape or pin the tracing to the block by one end. Copy the tracing onto the block with carbon paper. Remove this tracing and repeat the operation with the second one on the adjacent side of the block. Check that

Figure 25a & b Figure 25a shows barrelling, caused by a blunt blade. 25b shows blade coming out of wood which is not square.

the drawings are on the correct faces of the block. This is often done incorrectly resulting in a useless bandsawn blank. The wood is now ready to cut. There is usually one view of the carving which it is preferable to cut first.

The waste that you cut away (from the first side) must be taped back onto the main piece, so the fewer pieces of waste the better. (Fig 28). In the case of the head, I cut the full face view first, because the lines are simpler than the profile view.

The first, second, third and fourth cuts, Fig 26a, b, c & d, ignore small curves and corners and produce four large pieces of waste which can easily

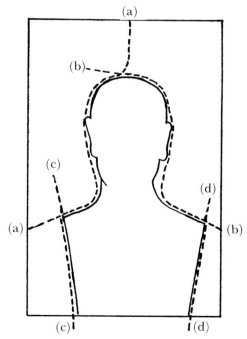

Figure 26 Sequence of bandsawing the figure from the block.

31

be taped back onto the main block. After these four cuts are made the small corners can be cut away.

Remember, that as a result of taking the photos correctly, enlarging them and tracing them onto the block, you have a very accurate drawing. Do not waste this by sloppy bandsawing. Ideally, the traced line should be split down the middle by the blade; this attention to accuracy will provide you with a sawn blank that can be directly related to the drawing and enlargements by measurements. In other words, you can measure the distance of the pupil of the eye from the side of the head and from the tip of the nose or the lips, on your enlargement, and locate it precisely on the wood. Time after time I have seen the cautious carver cut 6mm/¼″ or so outside the line, virtually throwing away the advantage he has achieved through photography, and leaving himself with the totally confusing problem of a figure that is 6mm/¼″ too large in every direction.

Before you start bandsawing consider in which order and in which direction you will make the cut. In thick sections of timber the sawdust will solidly block the cut behind the blade, preventing it from being 'backed out'. You may then find yourself locked into a corner and have to ruin your piece of wood or cut the blade. If you have to 'back out' the blade, do it every 10mm/⅜″ to ensure the dust is kept clear.

When you are faced with a very fine, delicate piece such as hands on a figure, or an area where you are not sure if your projection on the drawing is totally accurate (ie. a forward, outstretched arm) leave a good area of wood around it so that you have room to manoeuvre in the carving stage. And remember at all times keep your hands as far away from the blade as possible and never try to force wood when it doesn't want to cut — something is wrong, often a small sliver of wood stuck in the slot of the table. Incidentally, the small pieces from the bandsawing are waste and can be discarded.

When the first side of the block has been cut the main pieces of waste are fixed back in place with masking tape. (Fig 28). Use plenty, along every cut, side and end as well as round the whole block. If the pieces move you will produce an inaccurate cut on the figure, and it is dangerous. You may find that the surface produced by reassembling the block is uneven on the surface which must lie on the table; smooth this down with a chisel or plane.

Having reassembled the block you can now bandsaw the second face drawing. This does not need any special treatment, as all the waste pieces are discarded as they start to fall away. However, you may find that as the masking tape is cut through you need to apply more to stabilize areas already part-sawn; this must be done in order to prevent the block from falling apart before the cutting has been completed.

When the bandsawing is complete, the blank should appear as Fig 29.

Study this odd looking shape and compare it to the reference material to familiarize yourself with its relationship to the original model. Notice that the nose spreads right across the face. The waste pieces either side of a shape such as this will henceforth be called 'extensions'. Fig 30 shows where one extension of the nose has been cut away, while in Fig 79 in the female head shows forward extensions of the hair cut away.

Figure 27 In very tight bends, make a series of straight radial cuts into the bend before trying to saw; this will allow the blade to cut the tighter curves.

INSTRUCTIONS

STEP NO. 1

Apply a uniform coat of STATUARY BASE COAT to the object being gold leafed. Wash brush in soapy water. Allow BASE COAT to dry 60 minutes then proceed.

STEP NO. 1

STEP NO. 2

Apply a thin coat of GOLD LEAF ADHESIVE. Do not leave puddles. Wash brush out immediately in soapy water. As the ADHESIVE dries it will change from a milky white to clear. When completely clear, (60 minutes) proceed to STEP NO. 3.

STEP NO. 2

STEP NO. 3

With clean, dry hands, pick up a sheet of COMPOSITION GOLD LEAF and apply it to the sticky adhesive surface. Some overlapping is alright. When surface is completely covered, gently smooth out the leaf with fingers, a pad of cloth or a small soft brush. Small cracks and spots of BASE COAT will show through in places where the leaf has torn. This is desirable in order to give the authentic "Old World" appearance. Large spots may be patched with small pieces of leaf. Remove excess leaf with smooth, soft, and gentle strokings with a brush. When the surface is smooth proceed to STEP NO. 4.

STEP NO. 4

Apply a coat of SATIN SEALER. Clean brush in thinner. Allow SATIN SEALER to dry 2 hours. Proceed to STEP NO. 5.

STEP NO. 5

Apply ANTIQUING GLAZE working into crevices and corners. Gently wipe glaze over entire surface with a soft cheese cloth pad. Remove more GLAZE in areas you wish to highlight. Now wash brush in thinner and proceed to STEP NO. 6.

STEP NO. 6

After the ANTIQUING GLAZE is dry, (about 3 hours) apply a final coat of OLD WORLD ART SATIN SEALER. Allow it to dry about 2 hours before handling. Your project is now complete.

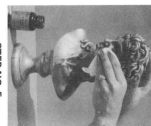

STEP NO. 4

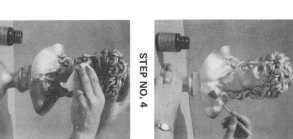

STEP NO. 5

STEP NO. 6

HELPFUL HINTS

1. Do not apply gold leaf over adhesive which has not turned from milky white to the completely clear state.

2. Gold Leaf and Composition Gold Leaf are very light in weight, therefore do not attempt to leaf in a windy or drafty area or this operation will be difficult.

3. If, after you have completed your project, you are unhappy with the result, simply allow the SATIN SEALER of STEP NO. 6 to dry, then start over at STEP NO. 1 and repeat the six steps of the process.

4. If the OLD WORLD ART "aged" look is not desired, simply make sure all cracks and crevices where BASE COAT shows are completely covered with gold leaf. Now stop after applying the SATIN SEALER in STEP NO. 4.

STEP NO. 3

Apply on picture frames, statuary, plaques, candelabras, art objects, lamp bases, lamp

Old World Art
EASY-TO-FOLLOW

HISTORY

The use of gold leaf to beautify dates back to ancient times. From the Egyptians through the 17th Century men have used gold leaf extensively in various art forms. As an example, magnificent statuary, plaques, and panels were carved from hardwood, such as oak, and then embellished with gold leaf. Many of these art objects still survive in museums throughout the world.

Gold leafing was also used on Medieval picture panels which often had gilded (gold leafed) backgrounds. In some cases panels were completely covered with gold leaf, then colours were applied over and around the leaf, which imparted a special splendor to the work. This style was characteristic of some Byzantine and Renaissance Art.

Among the gold leaf techniques used during these times was a method whereby a special ground colour, or basecoat was applied to carvings, and allowed to dry. It was then covered with a thick oil varnish which was allowed to dry to a critical stage, and then the gold leaf was pressed to the sticky surface. The gold metal was tooled and burnished to achieve proper shades and tones.

Often thin films of translucent colours were applied over bright colours such as gold leaf, to bring out the full brilliance of the base colour. These films, called glazes, were often applied with the greatest subtlety of effect. Titian and Rembrandt used the technique, Titian sometimes used as many as forty glazes to build innumerable shades and gradations of colour.

OLD WORLD ART

Through the years many attempts have been made to use modern materials to reproduce the elegance and charm of early gold leaf art. More recently, the use of aerosol spray cans of gold paint, acrylic lacquer and even gold paste waxes have been tried. The results have been less than desirable since it has been found that the distinctive cracks and crevices, the texture and tone of metal leaf can only be reproduced using materials and techniques similar to those originally used. Research into the origins and history of this ancient art has led to the development of the OLD WORLD ART GOLD LEAFING MATERIALS. These materials, used in conjunction with the OLD WORLD ART SIX STEP PROCESS enables one not only to use modern materials to achieve gold leaf effect, but to produce a genuine, authentic, centuries old final appearance.

The OLD WORLD ART RED BASE COAT, used in STEP NO. 1, contains Venetian Red pigment colours ground in a synthetic resin system. This unique combination of ancient and modern materials results in some unusual properties. The Venetian Red pigment contributes a proper base colour so that when cracks occur in leaf application, the exposed red colour is of an authentically "red earth" shade. In addition, the special resin base tends to seal the surface and then dries up rapidly in preparation for STEP NO. 2.

The OLD WORLD ART GOLD LEAF ADHESIVE used in STEP NO. 2, rapidly develops the sticky surface necessary for application of the thin sheets of metal leaf. The brush applied ADHESIVE has a built in indicator which tells when the leaf can be applied and therefore eliminates much guesswork.

GOLD LEAFING

The OLD WORLD ART COMPOSITION GOLD LEAF which is applied in STEP NO. 3 of the process is of the highest quality and is an import from West Germany.

The OLD WORLD ART SATIN SEALER used in STEPS NO. 4 and NO. 6 is a very special satin finish clear coating which seals and protects the composition gold leaf from scratching and tarnishing. It is easy to apply and resists running and dripping usually present in products used for this purpose. The rich satiny finish of OLD WORLD ART SATIN SEALER adds to the depth of colour and contributes heavily to the authentic "aged" appearance.

The OLD WORLD ART ANTIQUING GLAZE is used in STEP NO. 5 to highlight the brilliance of the gold leaf. It does not run or drip. It stays where it is put. This enables the artist to achieve proper shading, especially in the cracks and crevices of statuary. It has a long working time before it dries so that additional shades and tones can be achieved.

When you use OLD WORLD ART GOLD LEAFING MATERIALS you will follow the same basic steps used in ancient times. By following the instructions in this brochure you will reproduce the authentic look of gold leaf on statuary, plaques, candleabra, art objects, picture frames, lamp bases and shades, furniture or any wood, metal, glass or plastic surface or wherever your own individual tastes desires.

Regardless of the object you select to gold leaf, the OLD WORLD ART GOLD LEAF MATERIALS will revive the Old World beauty and charm. You will find the experience rewarding and enjoyable.

OLD WORLD ART
Ontario, California 91761

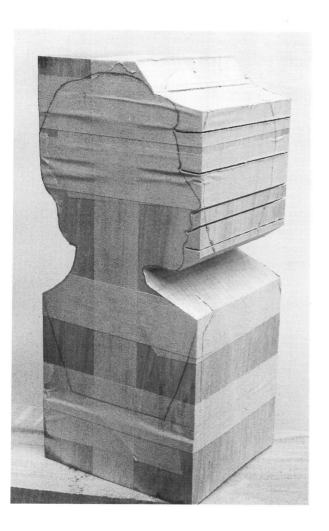

Figure 28

Figure 29

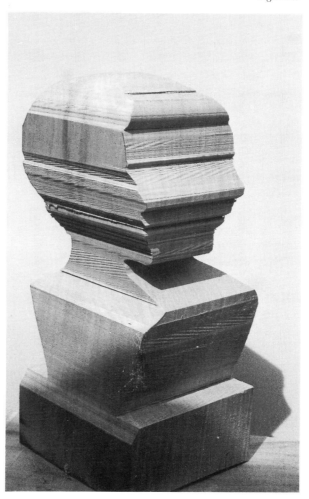

33

The carving

With the head securely mounted on a clamp or vice draw a centre line down the middle of the face, taking measurements from the drawings. Then measure the width of the nose at its widest point across the nostril, marking this on the wood. Measure the width across the nose between the eyes and mark this on the wood. Connecting these lines should give you a wedge shaped nose area. Similarly mark in the width of the chin and mouth (Fig 30).

All measurement of the front view should be made from the centre line outwards, thereby ensuring symmetry. Measurements vertically are made from easily identified reference points such as the tip of the nose, the bottom of the chin, the eyebrows etc. Side measurements use the back and front profiles of the head as reference points. Obviously, these will only work if the head is bandsawn accurately. As the carving progresses the forms are kept square for as long as possible to enable accurate measurements to be made. When they become more rounded this becomes difficult.

Taking a measurement from the drawing and transferring it directly to a curved surface is very inaccurate, therefore allowances must be made. For instance, when measuring the width of the nostrils, it is better to measure the base of the nose (ie. the top lip), rather than from the tip. Similarly, the width of the eyes can be measured on the forehead and vertical lines dropped down to the eye level.

The first areas to be removed are the extensions either side of the nose, from the eyebrows across the forwardmost projections of the eyelids, across the cheekbones, sloping forwards at the sides of the mouth to terminate at the chin.

Fig 30 shows one side completed and the other side marked, ready to cut. Using a 10mm/⅜″ No.5, or similar, gouge the wood away from the nose outward across the cheek, until the cheek is flat and the side of the nose wedge perpendicular to it. Do not chop down the side of the nose vertically into the cheek as this corner will be rounded when finished, and the gouge may cut deeply into the cheek.

Fig 31 shows the removal of the cheek areas completed. However, the face is still as wide as the complete head including hair and ears, as can be seen by comparison with the front face photograph. The next step, therefore, is to remove the waste areas and reduce the face to its true overall width. Using the drawings, take careful measurements from the centre line outwards to the extreme edge of the face and draw this onto the wood. Then, using the profile drawing Fig 22a & d, measure and draw in the hairline down the side of the face to the ear, the front edge of the ear and the hairline below the ear. Your head should now look like Fig 31

Carefully cut the wood away with a 10mm/⅜″ No.5, work back from the face to the hairline, then pare away the rough corner left at the hairline. Ensure with callipers that the dimensions of the face remain constant all the way back; ie. the width immediately in front of the ears should be the same as shown on the drawing, without widening as it goes back — a common fault. When completed, your carving should compare with Fig 32.

The next operation, rounding the skull, is a fairly simple one. Continue the centre line from the top of the face over the head to the back of the neck, then draw another line from ear to ear across the top of the head. These lines are the extremities of the skull and should be the only part of the bandsawn surfaces remaining at this point when it is rounded off. Using a 15mm/⅝″ No.5 gouge start from the forehead cutting horizontally across the grain of the wood working away from the centre line backwards towards the ears. Try to run the gouge around the curve of the head, modelling the form you require. Then do the same for the back of the head, working forward, continually looking down on the head from the top to see the shape you are making (Fig 33). Study the view of the skull from above, Fig 23d.

As the skull begins to take shape leave the area around the ear untouched — they protrude beyond the hair, although only a little. Gradually work upward and form the dome of the top of the head and when the shape looks similar to Figs 34, 35 & 36 tidy up the tool cuts and shave away the untouched area of the centre line.

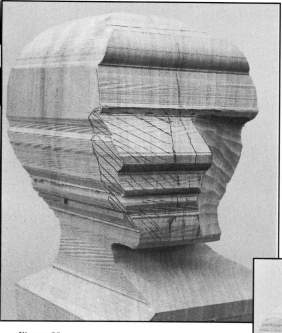

Figure 30

Figure 33 Direction of gouge cuts to round off the head.

Figure 31

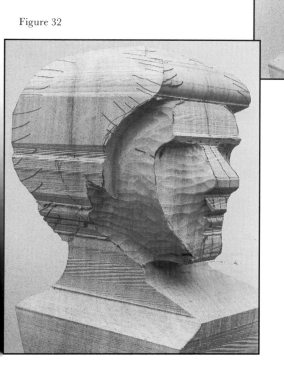

Figure 32

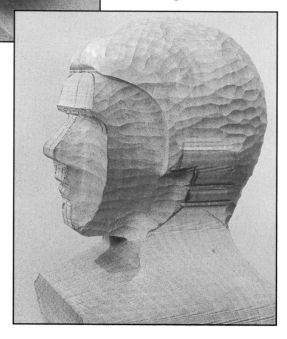

Figure 34

35

Figure 35

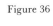
Figure 36

Figure 38

Figure 37 Hatched areas to show the wood to be removed to turn the shoulders in relation to the head.

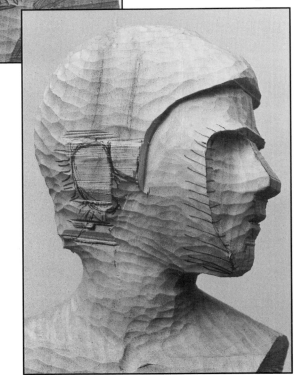

Looking at your head now it should be fairly obvious that the forehead which still has square corners should be rounded off. Study the shape in the photograph looking up the face Fig 49. This can be rounded using a 10mm/⅜″ No.5 gouge. Fig 36 shows this complete.

These shapes can now start to be checked against the cross sections, Fig 22e. Obviously, they will be far from correct at this point, but should be heading in the right direction.

We now have the very basic forms of the head, but the shoulders are still untouched.

The head is at an angle of about 20–25° to the axis of the shoulders on the finished carving, but as yet we have only a square block. It is necessary, therefore, to cut a 20° wedge from the front and back of this block to turn the shoulders in relation to the head. This sounds slightly odd but is actually quite simple (Fig 36 & 37).

Remember that the chest is on the left hand side of the head as you look at the face.

The drawing Fig 37 shows the top view of the carving. The hatched areas must be cut away to twist the shoulders slightly. The chest also slopes back slightly toward the collar bones. The back curves almost to the hairline at the back of the neck. Study other photographs of the model and the carving to see this.

When the carving looks like Fig 36 the tops of the shoulders are rounded over to the back and the column of the neck shaped. Notice that the neck slopes forward from the top of the breastbone. At the front it meets the shoulders in a fairly tight curve, sloping upwards and backwards (Fig 39 & 40).

At the back, see Fig 133a, two large muscles run upwards to meet the neck muscles.

Now that the main forms and planes of the entire bust are in place we can return to the face to start the second level of modelling. First establish the position of the ears. Using callipers, measure on the drawings the distance from the tip of the nose to the front of the ear and mark the wood accordingly, both sides. The upper and lower extremities should already be established by the bandsawing. It only

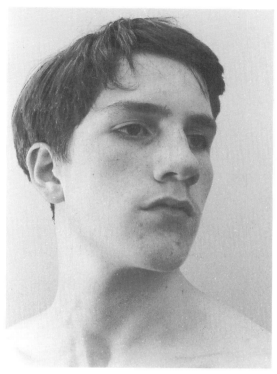

Figure 39 & 40 The photographs show quite clearly the bony structure of the face. Also the muscle twisting round the neck can be seen and the windpipe and Adam's apple pulled round to the right.

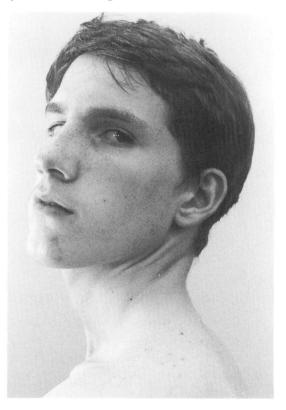

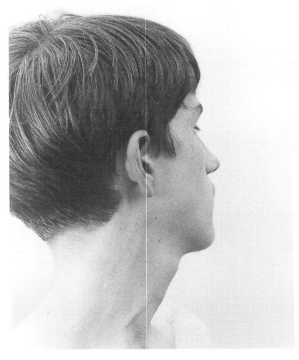

Figure 41 On this picture the profile of the eye socket, cheekbone, mouth and chin show very sharply. Notice the depth of the eyesocket, also the prominence of the collar bone.

remains therefore, to measure the width of the ear, front to back and draw in the rough outline on the head. The ear can be isolated by cutting around it with a vee tool or small gouge and trimming the hair away, Fig 38 & 46. The cheeks can also be rounded off on the corners marked in Fig 38.

Next we tackle the eye sockets. The forward extremities of the eyelids have already been established. Now measure on the drawings, Fig 22a, the rearward extent of the eye sockets and mark the wood. Then using a 10mm/⅜″ No.9, carefully pare the wood from the centre of the eye back in a curve to meet the edge of the socket, Figs 42 & 43.

In carving the eye our intention is to establish a raised mound in the eye socket, then cut the eyelid opening into the mound. The actual eyeball, such as is visible, can then be shaped — we know that it is a section of a sphere. Carving the eye is dealt with in detail on pages 44 to 48.

Fig 43 shows some hatching under the cheek bones and corners of the mouth. Reference to the anatomical head, Fig 24a & b, will show that the depressions are caused by the muscle action on the corners of the mouth and the bulge in the chin and

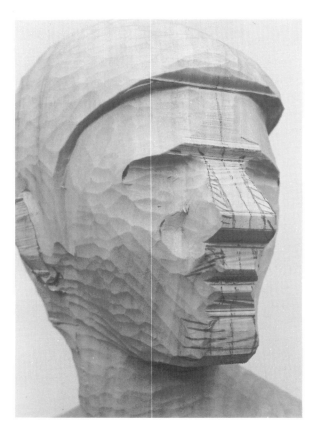

Figure 42

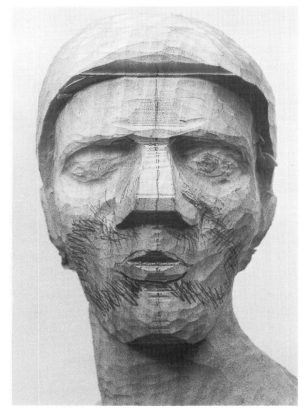

Figure 43

Figure 44

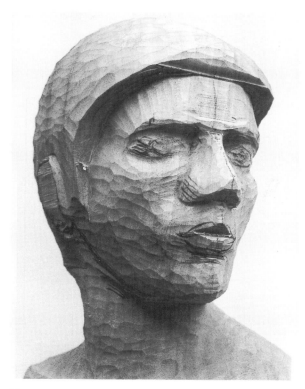

Figure 45

the prominent cheekbones and the lack of cheek fat in a youthful person, Figs 39, 40 & 41.

Pare this area away carefully with an 8mm/$\frac{5}{16}''$ No.3. Fig 45 shows this completed. At this point it would be useful to test the shape of the face against the cross sections Fig 22e.

In a fatter-faced individual the hollows under the cheek will be totally absent, even the reverse. Also the raised areas either side of the mouth may be deformed by sagging muscles, fat or pronounced facial expressions, Fig 44.

Now the nose, and this must be done very carefully. Check that the width of the nostrils you have already established is correct by measuring from the centre line across the base of the nose at the top of the lip. Now measure from the profile drawing, Fig 22a, the exact distance from the tip of the nose to the rear-most extent of the nostril. Using a 10mm/$\frac{3}{8}''$ No.5 cut into the cheek from the side towards the nose, Fig 47a, but not cutting into the nose. Pare back this area of the cheek until the measurement from nose tip to nostril is correct.

Clean up the cut up from the front. The completed cut can be seen in Fig 42.

Then measure the width of the tip of the nose and mark the line from the side of the tip to the bridge, Fig 42. The area hatched on the Fig 42 can be pared back making a wedge shape, Fig 43. The chin and top lip can be rounded — study the photo from below, Fig 49, and the cheeks rounded and hollowed slightly under the cheekbone, Fig 45.

Further refinement of the features can now be undertaken. Using a 3mm/$\frac{1}{8}''$ No.11, cut a smooth curve around the back of the nostrils. This is frequently cut in with a larger gouge as a sharp cut, but it is rarely a sharp corner in reality. Now, using a 6mm/$\frac{1}{4}''$ No.5, scoop out the depression between the nostrils and the tip of the nose. Next, use a rotary burr to excavate the actual hole of the nostrils. Study the photos of the nose carefully, Fig 48, 49 & 50, and observe the subtle curling shape around this area. Carry on below the nose and cut the groove between the nose and the top lip, using the burr again if you prefer.

Now we come to the mouth, in my opinion the most expressive and most difficult feature of the face. First measure from the centre of the lips to the point in the corner where the lips and cheeks converge. Observe whether or not the mouth drops down towards the ends. Draw in the meeting line of the lips and cut into this line with a 10mm/⅜″ No.2 or 3, following the curves. Now pare away the top lip and round off the bottom one, bit by bit, until the shape starts to appear (Fig 46).

Notice that the lower lip is set back from the upper, also that towards the outer corner the lips lose their edges and round inwards. This varies in individuals, some people, indeed, having virtually no lips at all. Observation of real people will show you that the physical boundary of lip is not quite the same as the red colouring, so be careful with photographs.

Between the top lip and nose is not usually just flat. In some young women, particularly of certain ethnic origins, the lip is distinctly turned outwards; in other people it is puffed out as if the lips were pursed. In the head we are carving there is only a slight hollow curve near the middle and a shallow groove running from the corner toward the middle. This can be seen in Fig 50, and is an extension of the swelling next to the corner of the mouth (this is the node, a fibrous lump where several muscles meet) which also causes the hollow below it. This tends to follow round under the lip which should be quite deeply undercut. These features can be seen from the side of Fig 48.

A variety of gouges are needed for this modelling from 3–8mm (⅛″–⁵⁄₁₆″), Nos.3, 7 and 9. Also a sharp knife to clean up the join of the lips.

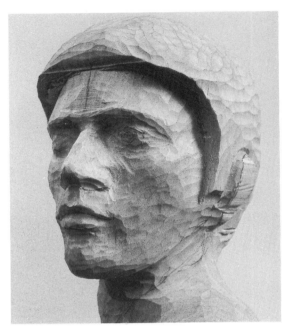

Figure 46

Figure 47

Figure 48 Observe the roundness of the corner at the back edge of the nostril — not a sharp cut as is so often seen on carvings. Also, compare the lips on this picture with 49, 50 & 51. Notice the excessively curvaceous line of the lips and the distinct division of the top lip into three sections — a bulbous central one and two sharply undercut side sections.

Note also that the central groove above the lip runs up towards the nose, then splits into two with only a narrow central section connecting with the middle of the nose, while the outside ridges run back and fade out.

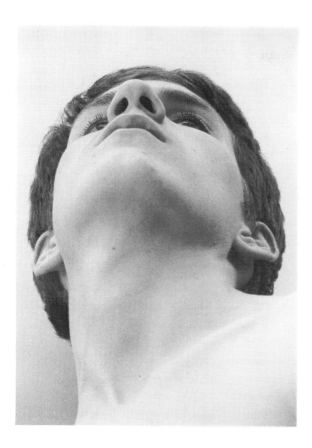

Figure 49 A most important picture, as the shapes you have made can be checked against this view to see that the cheeks slope back enough, the mouth is curved enough and so on.

Figure 50

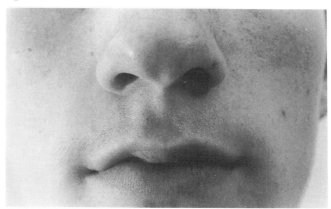

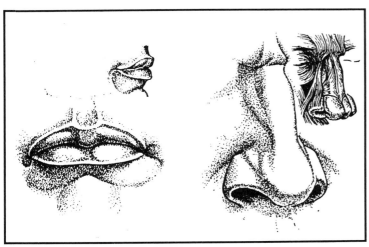

Figure 51 The mouth and nose shown here are drawn from Michelangelo's statue of David. The anatomical drawing shows the sections of cartilage which make up the tip and wings of the nostrils. Notice the 'edge' around the lips which cannot be seen in Figure 50, but is often used to good effect.

41

At this point we will study the eyes in more detail and carry out a separate exercise on a larger scale. Carving the eyes is not the most difficult part of the face, but the experiences of many students has shown me that it is perceived as such, mainly because there seems to be a basic misconception of the structure of the eyeball and its surrounding tissues.

The eyes seemed to be viewed as a lozenge shaped opening in the face, like a slit in the skin which opens onto a hole through which they look out. Everyone knows what an eyeball is, and yet this knowledge tends to be ignored. It is revealing to know that when blind people model a head in clay, they make a hole for the socket and pop in a ball of clay, presumably because that is what they can feel with their fingers. As you can feel, and see in Fig 53a & b, the ball is suspended in a squarish recess of bone slightly tilted upwards towards the nose. The upper edge overhangs the lower one, and the outside edge curves back some distance towards the ear, whilst the inner edge is bordered by the bones of the nose.

The ball is surrounded by a circle of thin muscle and covered above by the upper lid which opens and closes, Fig 53c & d, and below by the lower lid which tends only to contract and thicken. The

shape of the visible eyeball is rather like the segment of an orange. Observe how far around the face the visible eyeball curves on the outside and notice that the inside corner curves back into the deep recess by the nose — the inside corner cannot be seen in a profile view of the head (Fig 54).

If you feel and look at your eye in a mirror you will find that the bony ridge of the upper outside edge can be sharply discerned beneath the skin. Follow it towards the nose and it rather twists inwards and is taken over by the larger bony lump running from above the eyebrow to the top of the nose.

Under this bony roof on the upper inside corner is a deep recess shown as a dark space between the eyeball and socket on the drawing. Below the eyeball the bottom edge of the eye socket can be felt, but except on the most emaciated people, is obscured from sight by the loose skin or bags below the eye. As you run your finger around to the lower outside corner the bone can be felt and seen running backward and upward round the outer edge of the ball leaving a slight depression in the space between, until it again begins to overhang the ball and create a fold above the upper eyelid. Study the photograph from below, Fig 49, very carefully.

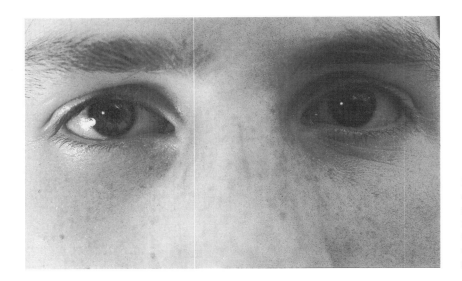

Figure 52 Note the deep overhang of the skin above the eyelid and the deep crevice on the inside upper curve — relating directly to the bone of the eye socket Fig 53c. Note, also, the way the lower lid curves tightly up around the outside curve of the ball, and the outward sloping edge of the lower lid.

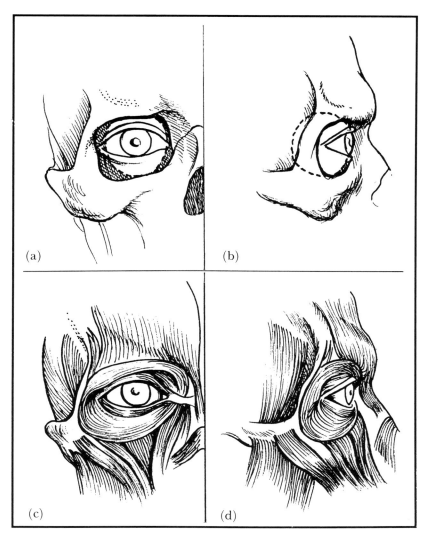

Figures 53a–d The bone and muscle surrounding the eye.

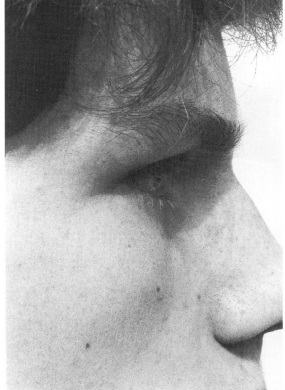

Figure 54 Although rather dark on the photo, the forward tilt of the eyeball can be seen. Also the extent of curvature round the side of the face of the eye opening. Note, also, the almost perpendicular drop of the cheekbone.

Eye carving exercise

The following section, Figs 55–69, shows the process of carving the eyes on a large scale to clarify the techniques involved. This should be practiced on a separate piece of wood and the method applied to the project.

Our first aim is to produce the overall shape of the eye socket with the mound in it which is the eyeball and lids, Fig 56. Check your shape against the cross-section A–A and B–B in Fig 55a, b & c. Carefully measure and draw the eye opening onto this surface. Always measure from the centre line of the face outwards. It is more accurate to measure to the outside corner of the eye and from there to the inside corner. The level of the eyes should be checked by measuring the distance from the line of the lips. Study the photograph Fig 57 and the view from below, Fig 49, comparing your carving from the same angle and refining the shape.

Now take a gouge which fits the curve of the upper lid, such as a 8mm/$\frac{5}{16}$″ No.3, lightly stab into the wood along the line (Fig 58). Notice the angle of the chisel which must slightly undercut the lid. Now pare the wood away on the top part of the eyeball, being very careful not to chip the lid (Fig 59). You may need to do this two or three times to achieve sufficient depth (about 3mm/⅛″ on this exercise) safely. The upper lid should overhang slightly more than in real life, in order to create the shadow normally cast by the eyelashes.

Now repeat the operation on the lower lid (Fig 60). Notice that this cut is made radially to the eyeball as the edge of the lower lid slopes outward rather than being undercut. Also of course it will not be as deep as the upper one. Having completed these two cuts, the eyeball should now be somewhat pointed across the middle rather than round. Using a small No.2 gouge to round off the ball (Fig 61).

Figures 55a, b & c This exercise demonstrates the techniques of carving eyes and is carried out on a block of limewood 250mm/10″ long and 100mm/4″ high; the eye openings, from corner to corner, 60mm/2⅜″ long.

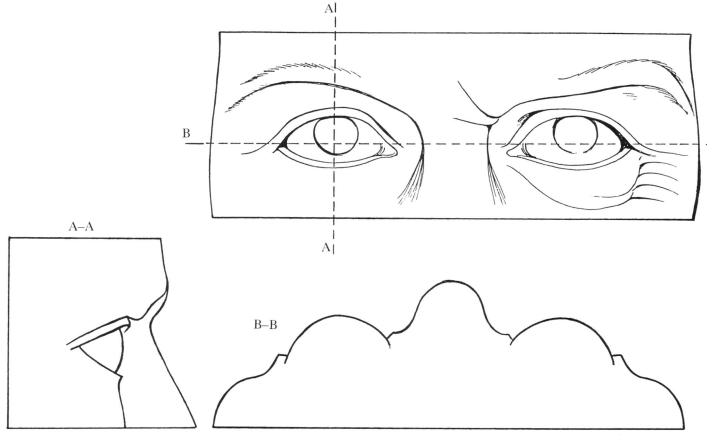

44

Figure 56

Figure 57

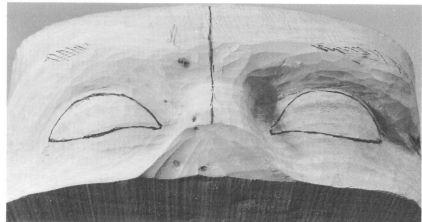

Figure 58

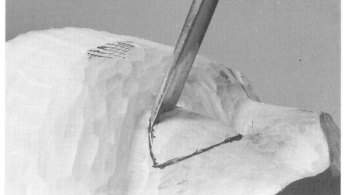

Figure 59

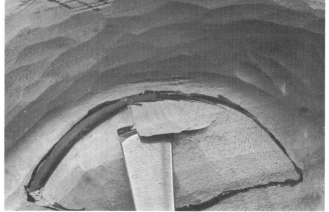

Figure 60

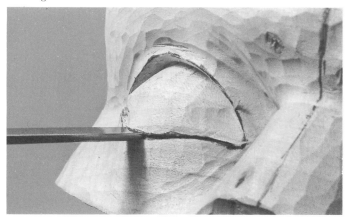

Figure 61

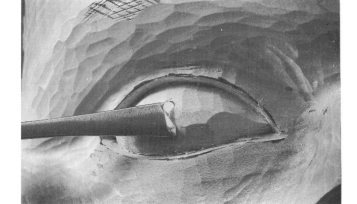

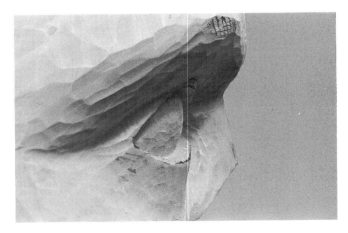

Figure 62

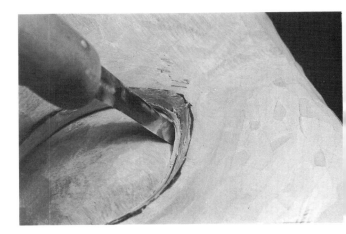

Figure 63

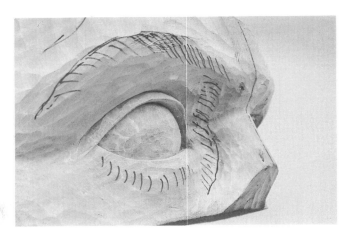

Figure 64

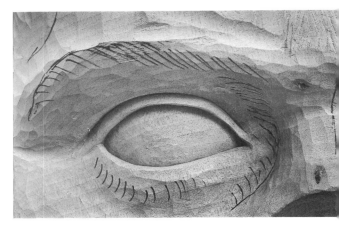

Figure 65

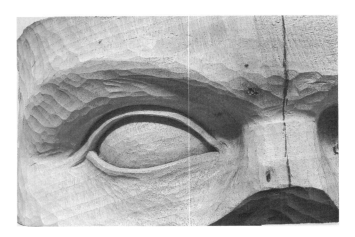

Figure 66

Now look at the opening from the side, Fig 62, and see whether the shape and size agrees with the drawings and photographs of the model. The eyeball should tilt forward slightly, that is the upper lid is slightly in front of the lower one. If this is not the case, the lower lid must be pared back and recut.

The eyeball will not be round enough or deep enough in the corners. Using a sharp pointed knife cut deeply into the corner of the lines of the lids, Fig 63, and slice away the triangular piece of eyeball until it has a really round shape and can truly be said to be a section of a sphere. Study the photographs and your own eyes. Remember that the answer is in the real thing, not in your piece of wood. Your eyeball should now look like Fig 64. Using a gouge of suitable curvature, cut in the groove along the top of the upper eyelid. Sharpen and deepen this with a knife. Fig 65 shows the same stage from the front. I have marked in the hollowing below the eyeball and running up between the nose and eyeball, and the shallow groove below the eyebrow which we must make to produce that feature. Use a No.5 and No.8 for these areas. Using the No.8 gouge run a shallow groove under the bottom lid, very slight at the inner end but getting more pronounced as it proceeds towards the outer corner. Smooth down the area below the groove. Similarly the groove below the eyebrow is very shallow at the outside edge and gets deeper as it runs into the inner corner.

The deep corner by the nose is difficult to cut cleanly and may need a 5mm ball-shaped burr to tidy up. Fig 66 shows the eye completed. Fig 67 & 68 show another eye somewhat older and frowning. This produces the familiar creases at the top of the nose where the muscles draw the eyebrows inwards and downwards. The creases at the corner and the bag below are symptoms of aging and contraction of the muscles around the eye. They are best cut in with a knife. Of course there are infinite varieties of eyes, some of which are remarkably different to those we are carving. However, an understanding of the basic structure and a little observation should enable you to understand what you are seeing.

When the carving of the eye structure is completed the eyeball can be sanded or smoothly tooled, as appropriate. Personally, I always sand the actual eyeball, regardless of the rest of the carving. On small figures I sand the eyeball before continuing to carve the eyelids, because there is a danger of breaking or abrading the delicate thin edges.

When the eyeballs are beautifully smooth and rounded, the next problem is the irises. There are several different ways of tackling this. The first would be to say that the iris is only colour and therefore has no form so the eyeball should be blank. However, closer scrutiny will reveal that the iris or the lens of the eye is in fact a separate convex form standing slightly proud of the eyeball and should have a shape. This I have never seen on a sculpture. We are familiar with the ancient Greek sculptures which display no irises, but archaeologists assure us that these figures were painted and had coloured eyes, sometimes inlaid with blue stones and adorned with bronze eyelashes.

Nevertheless, the tradition of blank eyes has persisted to this day. There is no doubt that on certain sculptures they seem right, and whilst direction and expression can still be achieved there is a feeling of anonymity which is perhaps appropriate, say on an angel.

The alternative is to cut into the eyeball in some way, either to create a kind of symbolic iris or an area of shadow that gives the illusion of the darker colouring of the real thing. This seems always to have been a problem. The carvings of the mediaeval German craftsman Riemenschneider display all three methods on one group of figures, indeed in addition to others which appear to be stained or painted.

There are two methods which I suggest using. The first, which is more difficult, is to carefully measure the irises and draw them onto the eyeball. Then take a No.9 (semicircular) gouge of exactly the same curvature as the iris and gently rotate it around the drawn line, making a slight incision. Then take a small flattish gouge No.2 or 3 and carefully pare away the edge of this circle thus leaving a convex disc, Fig 69 left. If the eye is large

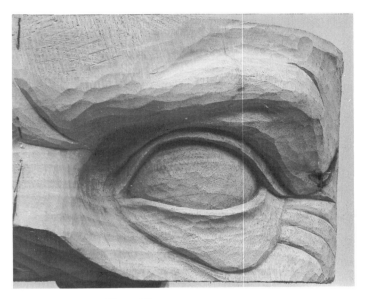

Figure 67

Figure 68

Figure 69

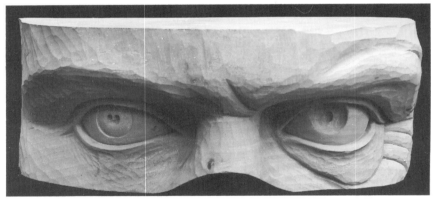

enough sand this smooth.

On many sculptures the pupil is simply drilled into the centre of this iris. On larger heads the drilling consists of two small holes side by side, which are then joined at the bottom making a heart shape, Fig 69 left, the point at the top remaining to catch the light, as on a real eye. This method can be seen, for instance, on Michelangelo's David.

The other method is to drill out the whole iris into a bowl, Fig 69 right. A rotary burr is best used for this, using a diamond burr to clean up. The

hollow can be taken up under the lid. This curved depression then catches the light and creates a variable shadow which has some affinities with the real eyes. The depth of it can be varied for lighter or darker eyes and if you wish, an even deeper pupil can be drilled into the hollow. In either method the size of the pupil can be varied according to the requirements.

Of course, eyes vary tremendously because of bone structure, aging, fat and the use to which they are put. (See also Fig 237 in project section).

The headband can now be carved. This is quite simply two parallel cuts chipped in at either side with a 15mm/½″ No.2 and slightly recessed with a 10mm/⅜″ No.3, Fig 70. It is also a matter of taste whether you include it at all. The hair above the headband can then be properly rounded into a dome. The fringe around the front needs rounding off until it meets the forehead, Fig 71. Spiky ends of hair are very difficult to carve successfully, and study of antique sculpture will show you the rarity of it. Hair invariably has to curl in on itself and blend into the head or neck. Clearly, certain types of hair carve very successfully, ie. the flowing wavy type, whereas others do not, ie. short spiky, stubbly or frizzy.

At this stage the neck and shoulders should be modelled. The chest dips slightly in the middle at the bottom of the carving but raises up more towards the point where the collar-bones come together. (See Fig 21a b c & d.) These protrude somewhat as they move away from the breastbone. Above the collar-bones the shoulders are set back forming a distinct hollow which then runs up and over the sloping muscles which run between the shoulder joint and the back of the neck. The actual neck protrudes forwards between these two muscles forming quite a sharp curve at the bottom. A groove runs from below the ear, under the jaw-bone and round under the throat. Down each side of the neck from the mastoid process behind the ear to the inner end of the collar-bone, runs a strong rope-like muscle. That which faces the front will stand out quite clearly as it is stretched and twisted. The far one will be more concealed in the fold between the neck and the shoulder.

At the back there is a depression between the shoulder-blade in the upper middle of which the vertebrae rise up quite distinctly; for further

Figure 70

Figure 71

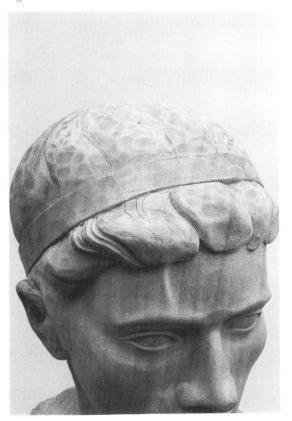

49

reference see Figs 127 to 133.

We now move up to the ear. Study Fig 72 & 73 carefully. There is considerable shape to the ear, apart from the obvious holes and convolutions within it. Cut the overall shape first and pare away the hair at the back to lift the ear away from the skull, Fig 70.

The easiest way to shape the inner folds is with a 3mm/⅛″ ball ended burr. Grind away the shape systematically referring to side and rear photos. A smaller burr may be needed in some places, followed by a diamond burr to smooth the surfaces. Make sure the ears are level by careful measurement with dividers.

To carve the hair. First cut the main wave forms in. Make these deeply formed and with some order to them. Little should need to be done to the area above the hairband. Next rough sand all these shapes to remove the sharp tool cuts, then using a very sharp 6mm/¼″ No.9, cut a few flowing gouge lines into the wave. Make them irregularly spaced, some running into each other, some complete lines from forehead to headband, others only part way, Fig 71. Now using a 3mm/⅛″ No.11, intersperse a few finer, sharper lines amongst the large ones. This is actually a difficult process to complete successfully and requires practise to judge how many lines to use and to acquire the dexterity to make them flow. They can easily look like corrugated iron or straw. Further details on carving

hair will be found at Figs 96 to 100.

To finish the carving the ends of the shoulders will need trimming back to be symmetrical Fig 74a, b, c & d.

Sanding can now commence, if required. Starting with 100 grit, sand the whole carving thoroughly and carefully, except for the hair. Fold the paper over and over to get small radii for the corners. This should remove all tool marks. Now work through 120, 150, 180 grits and you should have an eggshell finish. The hair can also be rubbed down with the 180, but be careful not to reduce all the gouge cuts to meaningless marks.

Next dip the whole head in very hot water and leave it overnight to dry. The grain will have become rough and bristly. Sand again with 240 grit and the wood should be perfect. Sadly, you will probably find nasty little marks in the corners of the eyes, the nostrils, the mouth and the ears. Work at these with 180 then 240.

To polish the carving apply one thin coat of clear cellulose sanding sealer and leave overnight. Rub down, working carefully into every detail, with 400 grit sand paper. Apply a second coat of sealer. This should dry to a smooth semi-gloss finish. Rub this down thoroughly with 0000 steel wool and then wax polish. Good quality furniture wax is fine, but avoid letting the details get clogged with wax as this will be difficult to remove if it dries. After a few weeks another coat will be necessary.

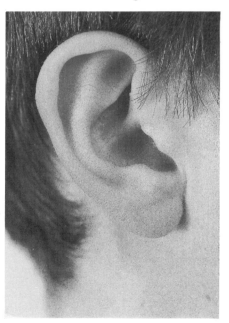
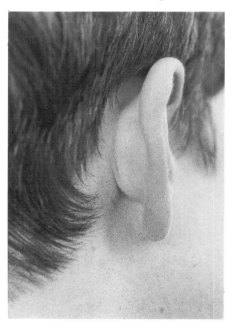

Figures 72 & 73 By studying the back view of the ear and observing the considerable depth of it away from the skull it is clear that the interior is equally deep. The ears stick out more than one expects and are more shapely in the form of a shallow 'S'. Notice there is no hair immediately around the back of the ear revealing the mastoid process to which the sterno-mastoid muscle is attached (see Figure 22).

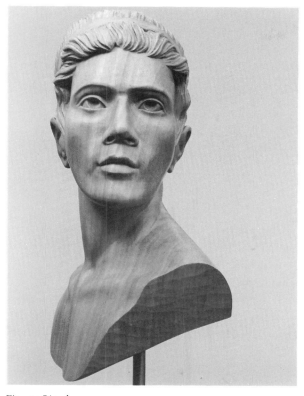

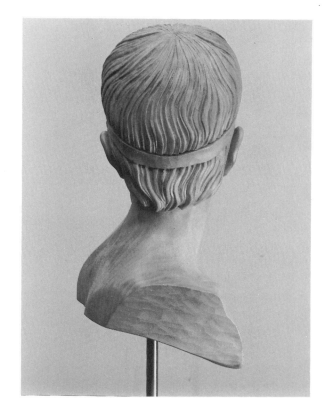

Figures 74a–d

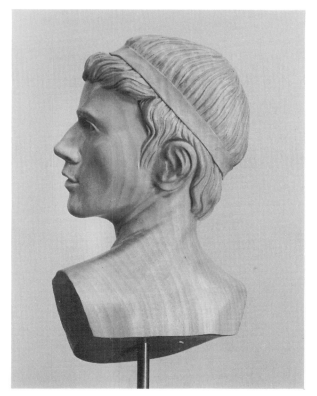

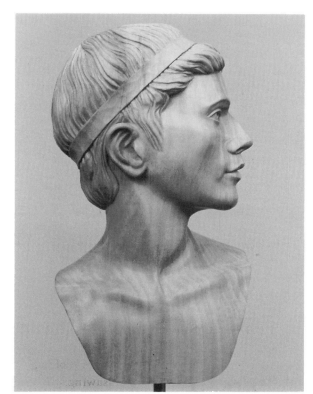

The Female Head

WHAT are the structural differences in the male and female head? Generally the female forehead is rounder and more upright because the bony ridges above the eyebrows are more prominent in men and sometimes absent in women. The chin on the male is more squared off and blunt, the woman's being more pointed with the bony projection in the middle less developed. The mastoid process, the lump behind the ear, is smaller in the female.

Bearing these anatomical facts in mind study the photographs of the male, Fig 21, and female, Fig 76, as individuals and compare them. There are few differences. The boy has higher cheekbones made more prominent by having less facial fat on the cheeks. The nose is somewhat turned up on the girl whereas the boy's is larger and more bony. The female chin is less prominent and somewhat receding making the bottom lip fuller. Contrary to the usual anatomical facts the female brow ridges are quite as prominent as on the male. Generally the girl's face is softer and chubbier, particularly around the jaw, and below the chin. The girl's face, being ten year's older, has slightly more lines around the mouth and eyes. Apart from these subtle variations there is nothing that actually makes carving the female head different from the male. My intention is, however, to attempt to increase the femininity of the girl. This will become apparent later in the carving process.

The process of generating the working drawings is the same as in the previous chapter, the only complication being the hair. The unruly strands have to be removed from the right side of the neck and made into a more solid clump.

Because there is a considerable amount of hair, the first stage in carving after bandsawing will be to cut this away from the face. This is shown hatched in Fig 78. Measure the dimensions of the face carefully, outward from the centre line, then the hairline on the profile drawing, Fig 77. When you are satisfied with your understanding of the area to be removed, cut it away into a square corner leaving the face projecting, Figs 79 & 80.

The carving of the face will then proceed in the same way as for the male. Compare the view of the head from above and below, Figs 83 & 84, with the male equivalent, Fig 49, and observe the differences. Use these views to get the shape of the face correct, Figs 82 & 85.

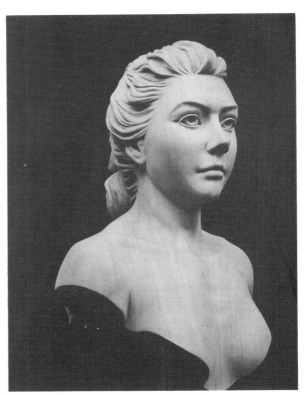

Figure 75

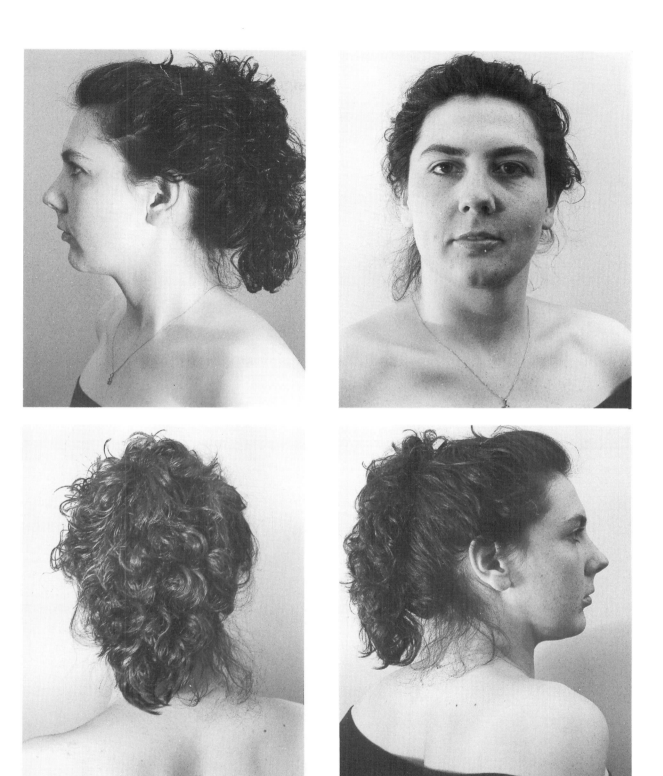

Figures 76a–d Compare these photographs carefully with male model, Figure 21. Notice the fullness of the face in the female compared with the bony, more sculptured male. The face is shorter and wider in the female, and the whole profile is curved, whilst the male's is basically straight. The girl's neck is also less stringy and sinewy, and the bones less sharply defined.

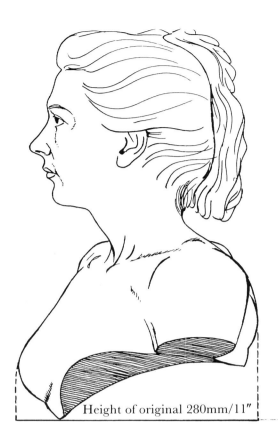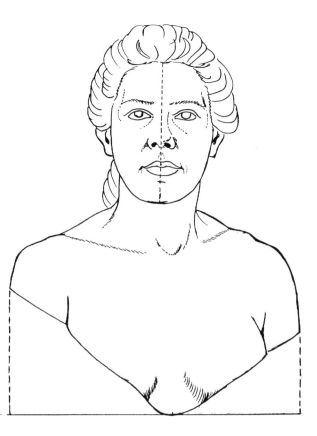

Height of original 280mm/11″

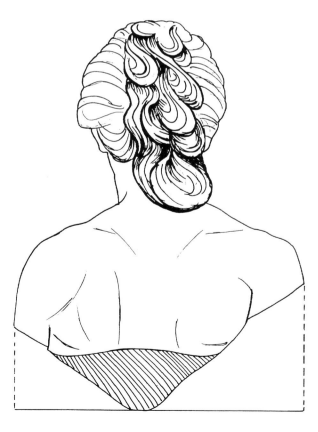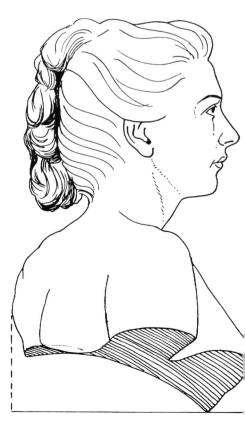

Figures 77a–d

Figure 78

Figure 79

Figure 80

Figure 81

Figure 82

Figure 83

Figure 84

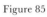

Figure 85

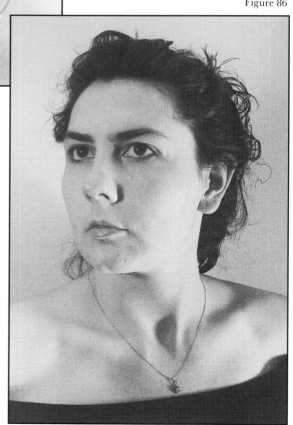

Figure 86

Figure 87 The mouth is quite small, little wider than the nose, which is itself narrower than the males. Notice that the nostrils in the male are set at about 90° to each other whilst seen here are almost parallel.

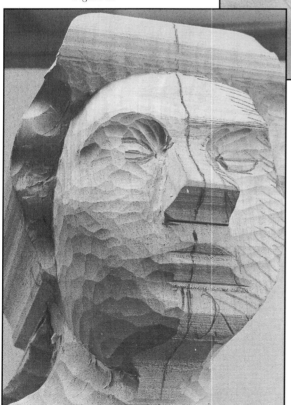

Fig 85 shows the modelling of the cheeks in progress. Notice the fuller roundness of them, less hollowing below the cheekbones and the little swelling around the corners of the mouth, Fig 86.

Fig 88 shows the head ready for detailing. The level of the front of the eye has been established and is ready to cut. Comparing this stage with the profile photograph of the live model, Fig 76d, certain discrepancies will be observed. The upper lip does not connect with the nose at the correct angle, making the nose appear too long.

For the purposes of this carving this may not matter and can be corrected somewhat, but if it were a true portrait, the whole face would have to be dropped back 6mm/¼″ to re-establish the nose. Also, the forehead is not sloping back enough, and the eyebrows appear wrong, both easily corrected.

Fig 89 shows the eyes in progress. These must be most carefully and perfectly done on young people as they are so smooth skinned and free of wrinkles. Older faces are actually easier.

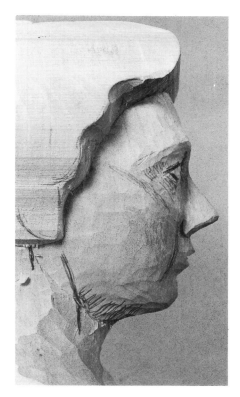

Figure 88

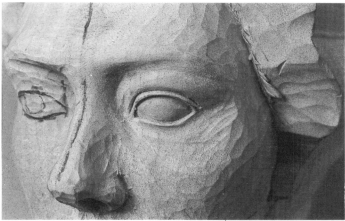

Figure 89

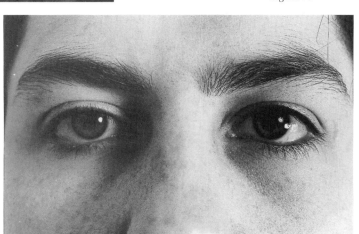

Figure 90

Figure 91

Fig 91 shows the face completely carved and roughly sanded. The neck and shoulders have been modelled and marked in for final cutting to shape. I find flat bottomed carvings rather heavy looking. Cutting off the corners lightens them, but does create a problem holding the work as it leaves a minimal area of wood at the bottom for screwing into. Complete the tooling of the underside edges to a finished surface. Then the rest of the back area, as marked in Fig 92, must be cut away, hand held.

The portrait we have so far, Fig 93, is not very flattering, indeed wood is not a very flattering material for a young face. We can, however, make a few alterations to improve matters.

Firstly, we slim down the cheeks very slightly and smooth away some of the folds and creases, such as from the inside corner of the eye across the cheek and from the nose to the corner of the mouth.

The furrow across the brow is removed by reducing the brow ridges, mentioned earlier, a rather masculine feature. Also, the eyebrows are raised somewhat to give a more alert appearance and less of a scowl. The overhang of the upper eyelids is lightened a little. The outer corner of the eyes are raised very slightly and the bagginess below the eyes reduced. The curve under the bottom lid is slightly deepened and softened (Fig 94).

Figure 92 The block for this piece was laminated, which many readers will also have to do. This picture clearly shows the disadvantages although the wood was carefully chosen from the same piece. It is extremely difficult to conceal a joint on limewood.

58

Figure 93

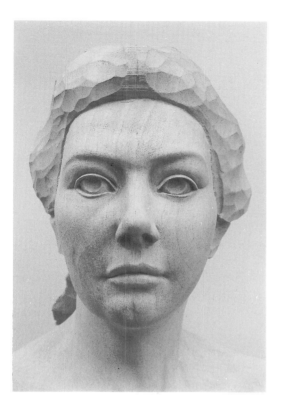

Figure 94 The process of sanding has begun on the right-hand side eliminating the groove from the inside corner of the eye across the cheek, softening the crease below the lower eyelid, raising the eyebrow and smoothing out the corner of the mouth.

must create an impression. Similarly, stubble would be a problem, as would bristly, spiky hair or wild, tangled hair. Look at carvings in museums and books and you will see smooth, well kept waves, and tightly combed locks. Leaving spikes of hair sticking out is difficult to achieve and does not look very good. The ends must be tucked away and folded under one another. Thus, in the carving in hand, the tangle of curling tresses at the back of the head must be left aside and made into a comprehensible form. True, it could be carved a little more naturally than I have done it, but then, we are learning.

As can be seen from the finished carving, Fig 101, and the drawings, Fig 77, the hair has been arranged into a series of hanging loops, pulled back from the hairline all around the face.

Figure 95

Finally, the lips are softened and rounded by sanding, the top lip thickened a little, and the lower lip undercut to give slightly more pout, and the chin tapered and smoothed. Almost all of this can be done by careful sanding (Figs 94 & 101a).

We now come to the hair. The method is the same as on page 62, but far more complex. The mass of untidy curls must be organised and formalized into a carvable arrangement.

For all practical purposes it must be accepted that much of the hair we see on real people is uncarvable. I say this with fear of being contradicted by great examples of the carver's skill which show me to be wrong, but these will be rare exceptions. Scale is also a factor. For example, to carve the short crinkly curls of an African on a 50mm/2″ head is fairly straightforward because the scale reduces it to a homogenous texture which we can approximate (see Jazz Dancer, Ch. 11). However, on a half life-size head we are faced with a prodigious task — possible, perhaps, by a highly skilled and dedicated carver — but normally we

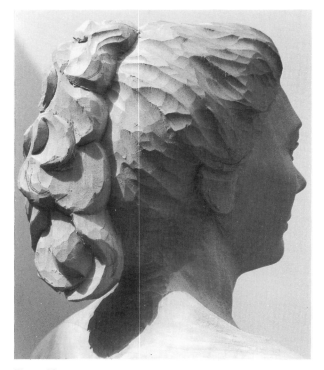

Figure 96

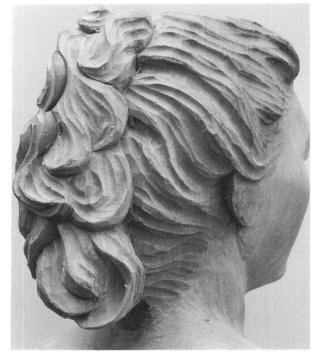

Figure 97

Figure 98 The gouge on the left has been ground with the wings forward for smoother cutting. The gouge on the right has the wings ground back for undercutting.

The first stage in carving this is to isolate the rear group from the head and shape it into the basic shapes of the loops, Fig 96. The main part of the hair is also carved into the major bunches. This is tooled to a fairly smooth surface, then roughly sanded to eliminate the angular tool cuts.

Next using an 8mm/$\frac{5}{16}$" No.11 gouge, heavy deep gouge lines are cut into the surface following the flow of the hair. The sweep of the loops is quite tricky but it is the flow of the cuts that is important. (Fig 97). Fade the cuts away as they reach the neck and temples.

The hanging part must be sharply undercut so that the gouge cuts fall away as you make them. You will find it advantageous to have two sets of these gouges; one set with the curve of the gouge ground back, the wings pointing forward, which cuts more smoothly and easily; the other with the wings ground back and the curves protruding, (Fig 98) to cut under the overhang of other locks of hair. The whole can now be sanded again.

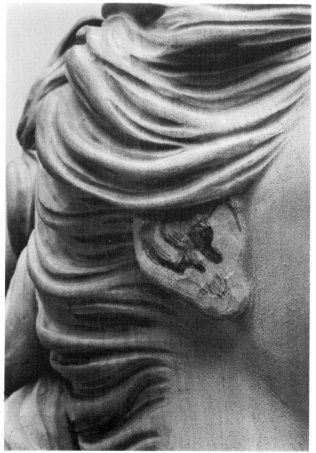

Figure 99

Finally, another series of gouge lines are made using a 6mm/¼" and 3mm/⅛" No.11. Try to keep the flowing lines and to make the cuts irregularly spaced and of different depths. When complete these can be given the final sanding, being careful not to flatten them down, Fig 99.

The ears can also be completed at this stage Fig 95 & 99 by the same method as in the male head, Fig 70, 72 & 73. The finishing processes are the same as the male head.

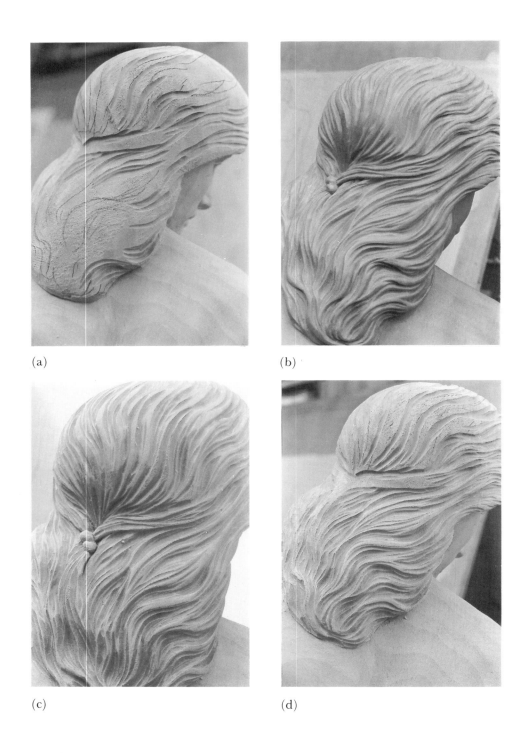

(a)

(b)

(c)

(d)

Figures 100a–d These pictures show another example of hair being carved, on a small scale, the head being about 100mm/4″ high. 100a shows the basic shapes being established having rough sanded the whole of the hair. In 100b these cuts are deepened and flowing gouge cuts of two different sizes made. In 100c this has been completed and the detail of the tie established. Finally, in 100d, the hair has been fine sanded and a few cuts with a very small gouge incised to heighten some of the forms.

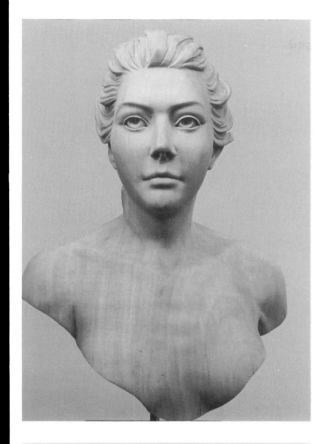
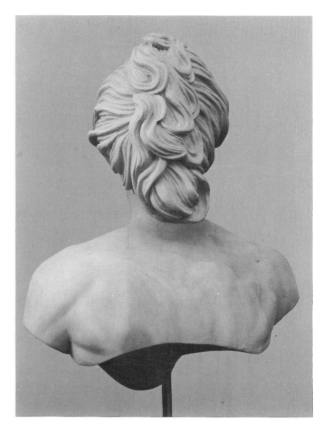
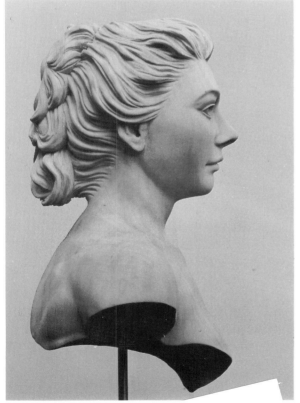
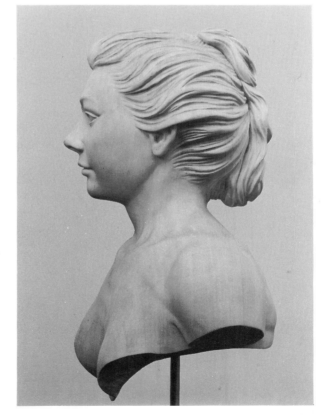

Figures 101a–d

The Male Figure (The Archer)

FOR centuries man has made images of the human body virtually all of them stylized or idealized to a certain extent. As Sir Kenneth Clarke makes clear in his book 'The Nude', the nude is an art form, it is not a reproduction of people without clothes. In the past artists trained for years to paint or sculpt the human figure by studying anatomy, drawing from life and from plaster casts and by copying the work of their illustrious predecessors. This vast accumulation of knowledge and skill was then used to create their own vision of the beauty, power, elegance and so on, potentially in the nude figure. Today we do not have these benefits, indeed in some art schools in the sixties life-drawing was banned and the plaster casts destroyed. Such is the march of progress. For those of us who wish to emulate the masters of old there is little comfort. We must use the anatomy books that are available, photographs and what live models we can find. For woodcarvers, and no doubt stone carvers, the difficulty is accentuated because, unlike the painter, we seek not just the two dimensional play of light, shade and colour on one aspect of a body, but every form, every plane and hollow, every bump and wrinkle and must cut it laboriously out of wood. Not too difficult given a few measuring instruments and a live model who will hold the pose for three or four weeks. And even then, if that is the answer, why is it so difficult to carve one's own face or hand? The answer is, I feel, that our eyes are not trained to see three dimensional shapes nor our mind to comprehend them, and we cannot adequately analyse the shapes because we do not understand what creates them. This is why photographs alone are so limited in their usefulness. People ask me why I spend so much time on

anatomy when I have perfectly good photographs in abundance. Look at the picture of the model's back for the jazz dancer Fig 220. What do you see? Shadows and highlights, lumps and bumps, bone and muscle. But to try to put a chisel round them! Now look at the semi-carved back Fig 221 with the muscles labelled and relate this to the anatomical diagram and some pattern begins to emerge. If the workings of the bones and muscles are studied we will begin to understand what we see in the photograph and be able to interpret it, rather like reading a contour map. The method, then, that I am using in this book is to establish a desired pose, to obtain photographic reference material by use of a model, to produce working drawings from the photographs along with anatomical studies, to rough out the carving and then apply the anatomical information directly onto the figure, and finally to alter the anatomical model to suit our own preference.

The Work

Let us now take the carving of the male figure presented here, from the first concept to the finished article. It was made, as were all the studies in this book, for this specific purpose. This particular pose was chosen because it is simple and relates closely to the typical anatomical figures in books. Also, it is a classical pose for a male nude, closely resembling the statue of David by Michelangelo and many other figures from ancient Greece to 20th century America. These classic forms, and there are only a few, tend to have a

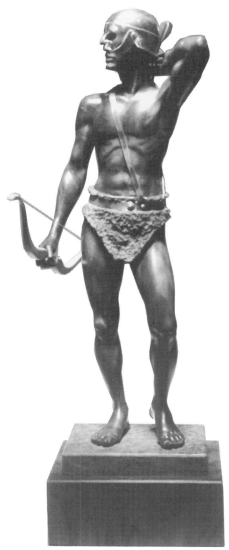

Figure 102

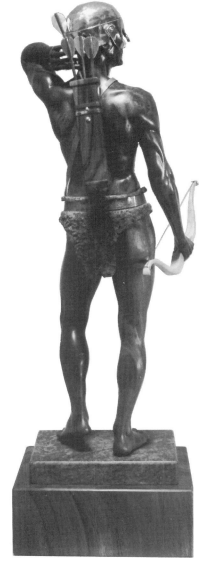

Figure 103

65

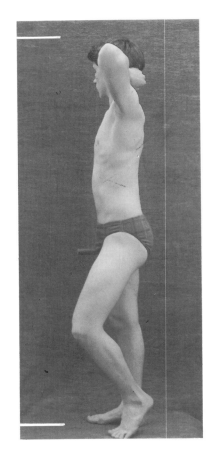

(a)

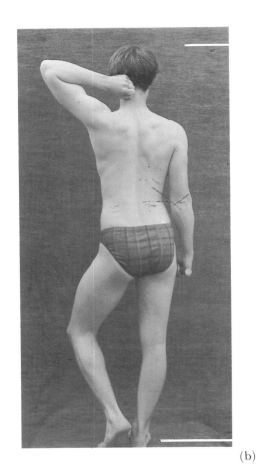

(b)

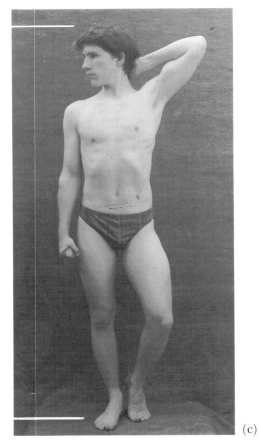

(c)

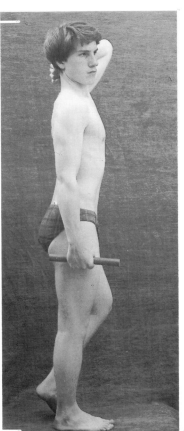

(d

Figures 104a–d

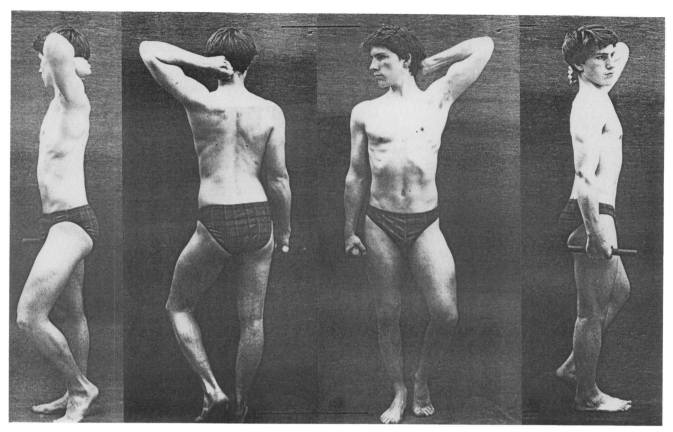

Figures 105a–d

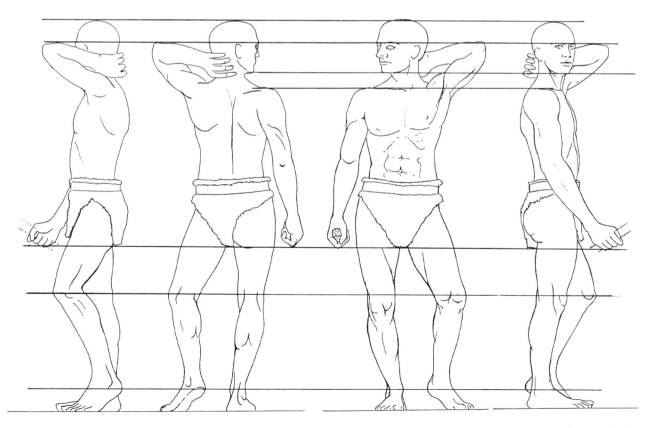

Figures 106a–d

stability and unity which can easily be lost in using more adventurous compositions.

I gave it the title The Archer because the model, a 16 year old boy, was not particularly muscular, conjuring up the vision of the Greek hero Paris, who shot Achilles. Also, Paris is usually shown wearing animal furs, and presumably wore a helmet. These accoutrements can of course be discarded, but I find people seldom want to carve fully nude male figures. Two side views are shown in Figs 107 and 108.

Proportions of the body

Dividing the body into ratios and fractions of certain features is a practice that is as old as art itself. It has been done for various reasons from the ideal of physical perfection to astrological observations; some have resulted in gross distortions and others in figures of great beauty. These proportions have varied widely, but today it is usually accepted as 7½ head lengths to the complete body length (including head). This gives a reasonable average type of figure. Obviously, in detail, it bears little relation to nature. However it does have its uses as a basic guide to the position of the bodily features.

In most modern books Fig 110c & d will show that the first measurement is from crown to chin, the second passes through the nipples. The third head length reaches the navel, the fourth the point where the legs meet and the fifth somewhat below halfway down the thigh. The sixth runs through the calf and the seventh the ankle, and half head length to the ground. These head lengths can be divided into two halves through the eyes and the points that they run through are the notch at the top of the breastbone, the top of the stomach near where the ribs meet the breastbone, the top of the cleft of the buttocks, the point in the thighs where they start to touch above the knees and the bottom of the kneecap. The same head lengths are used on the arms and run through the points where the arm joins the chest, the point where the elbow folds, an area just above the wrist, and the finger tips. Bear in mind that even on contemporaneous illustrations these will vary — they are not facts, only an

opinion, but they can provide a rough guide to the proportions of a figure. Similarly, it is often said that the eyes are halfway between the top of the head and the chin; the tip of the nose is halfway between the eyes and the chin and the mouth halfway between the nose and chin. The distance between the eyes is put at one eye length.

Most artist's anatomy books will go into greater depth on this subject. I have only marked in the head lengthwise on the skeleton illustrations Fig 110c & d because I do not think the subject worthy of more in this book.

The basis of the methods I recommend is the use of photographic reference material from live models — to start trying to alter real people to fit ideal proportions would only confuse an already difficult subject.

The process of changing photographs into working drawings is a difficult but vitally important one. The photographs have perspective because the subject has been viewed from a particular point. The working drawings must have no perspective, every part of the figure being viewed from a point exactly horizontally and vertically level with it. In practice, this means we must be looking at the head at head level, at the stomach at stomach level, at the knees at knee level and at the feet as if our eyes were at the level of the feet. Thus in Fig 104c we appear to be looking down at the feet, and one foot is higher than the other. In the finished drawing Fig 106c we are looking directly at the front of the toes, and both feet are on the same level surface. Getting from one to the other is the problem.

Assuming your photographs are the usual ones, about 150 x 100mm/6″ x 4″, have them enlarged on a photocopier to a more workable size, say about 300 x 200mm/12″ x 8″ (roughly A4). In the process of doing this, the sizes of the actual figures can be equalised. As can be seen from the photographs, although the figures are approximately the same size, the supporting leg for example, to the bottom of the heel, is a different length on all the pictures — this is caused by perspective. We must therefore create a datum line to work from, in this case about halfway down the foot in Fig 104c. The measurement from the top of the head to this line

will be the length of the figure. In the other photos the datum line will be the sole of the foot in Fig 104a & d and halfway up the foot in Fig 104b. The photocopies therefore must be enlarged so that the length of the body by this measurement is exactly the same in all four. This has been done in Fig 105.

The photographs must then be arranged on a drawing board, the datum lines aligned. By drawing lines across significant points on the figure, differences will be seen, noticeably in the feet, legs and raised arm. We must therefore take the most accurate views of the different features and use them as the basis of the drawings. For example in Fig 104a the raised arm is obviously foreshortened and distorted, but is quite accurate in Fig 104b & c, so those views are used to judge the height of the

hand, elbow and shoulder, and side views Fig 104a & d altered to fit. Similarly, the side views 104a & d of the supporting leg are more accurate than the front and back views 104b & c. In this way points all over the figure are checked and cross referenced on the four views.

The front view and one side view should be simply reversed and the outlines used for the outlines of the back view and the other side view, thus ensuring perfect similarity. Tracings are drawn and re-drawn until everything matches, resulting in drawings like those in Fig 106. These will look rather odd and different to the photos because of the lack of perspective. Any alterations you wish to make for artistic reasons are also made and your drawings are ready to use.

Figure 107

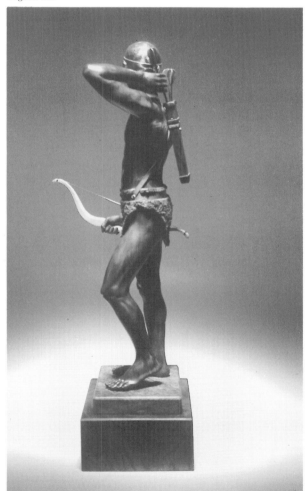

Figure 108

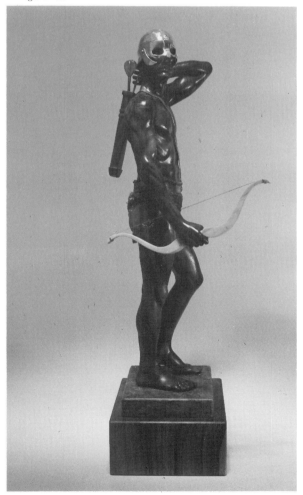

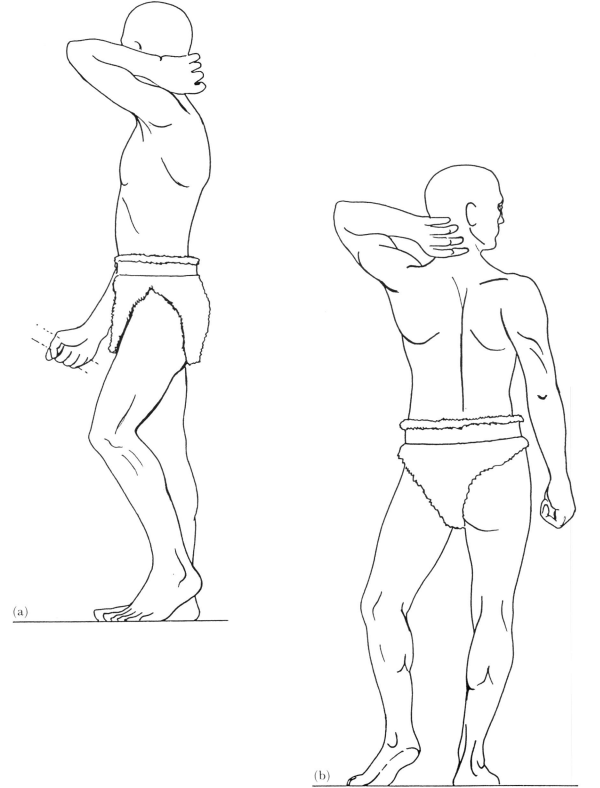

(a)

(b)

Figures 109a–d These master drawings were made up from the photographs in Fig 104. When bandsawing, trace Figs 109a & 109b onto adjacent sides of the block. Do not bandsaw between the legs, and leave a little extra wood around the fingers of the raised hand on 109a.

70

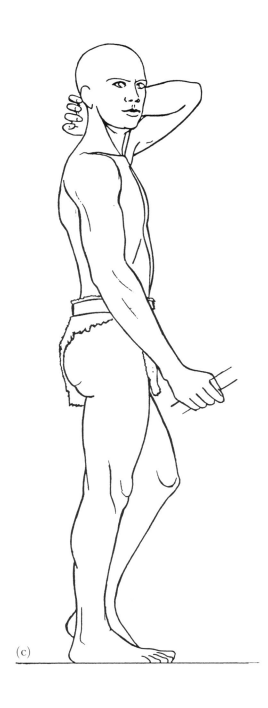

(c)

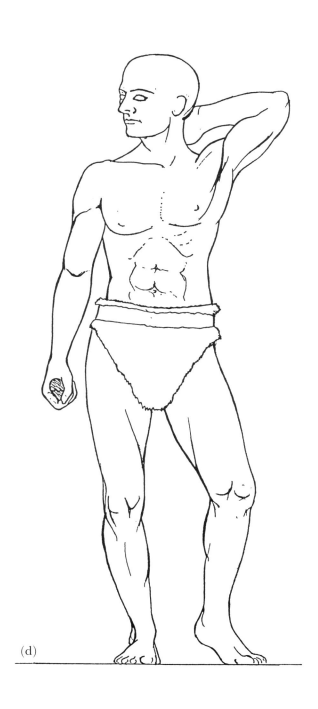

(d)

71

Figures 110a–d Understanding the basic structure of the skeleton, not in the minute detail of each bone, is vital to understand the body and to make up your working drawings — remember, bones do not change, they are a constant reference point for measurement. Compare these drawings with the muscle diagrams and study the way this complex system of levers and pulleys works.

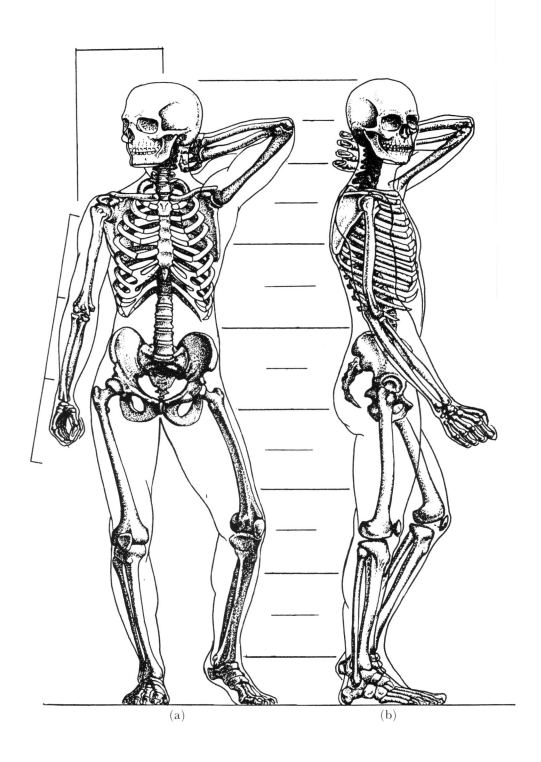

(a)　　　　　　　　　　(b)

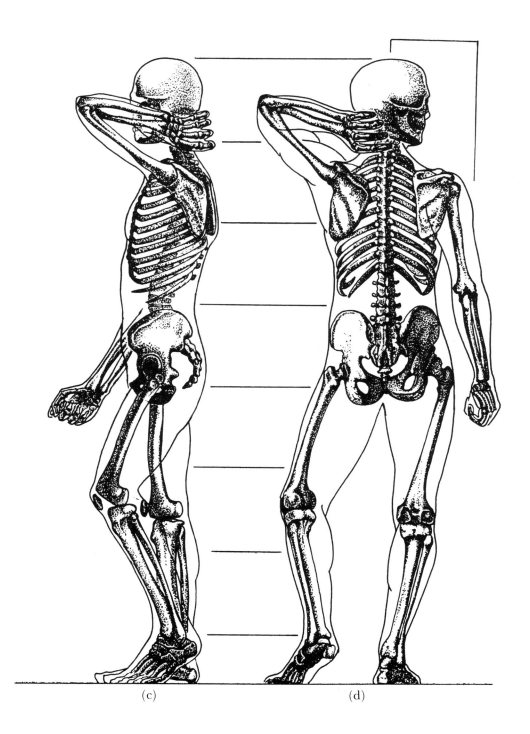

(c) (d)

Figures 111a–d This, without the skin and a few bits of fat (more on women) is what we see. Study the areas where the bones are not covered (dotted) — most of the skull and sides of the cheek-bones, the edge of the bone running down the back of the forearm and elbow, the top edge of the shoulder-blade and the collar-bone. Also the breastbone, the top edges of the pelvis, the spine, the hip-bones, the knee-caps and some small areas at the sides of the knee-joints, the shin-bones and the heels. These are landmarks on the body — study the photographs of the live models to locate them.

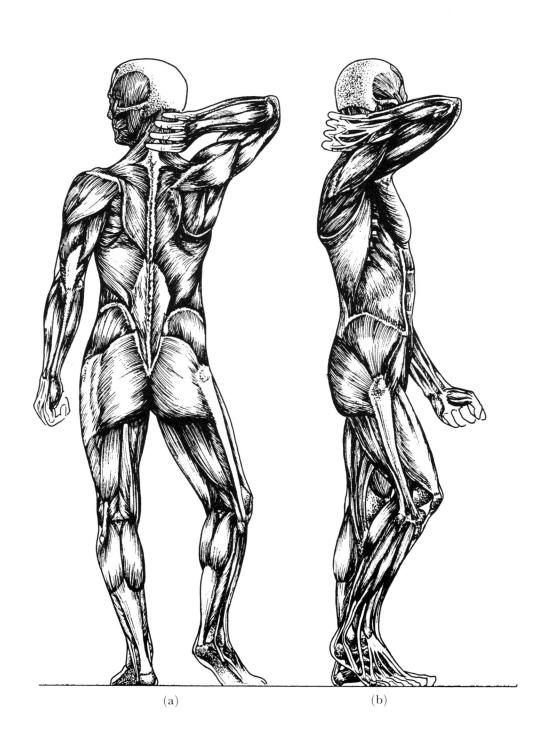

(a)

(b)

Figure 112, right. This is the body sectioned across the lines A–I in Figure 111c & d. Although the body is viewed from below, the cross sections are drawn square-on. When you are carving the figure, these cross sections can be compared with the carving by eye, or by photostatically enlarging them to the size of your carving and using a profile gauge to test it with. Alternatively, one might go to the trouble of cutting them out and using the negative shape to test with. The cross sections can be related to the anatomy drawings so that the shape of the individual muscles can be ascertained.

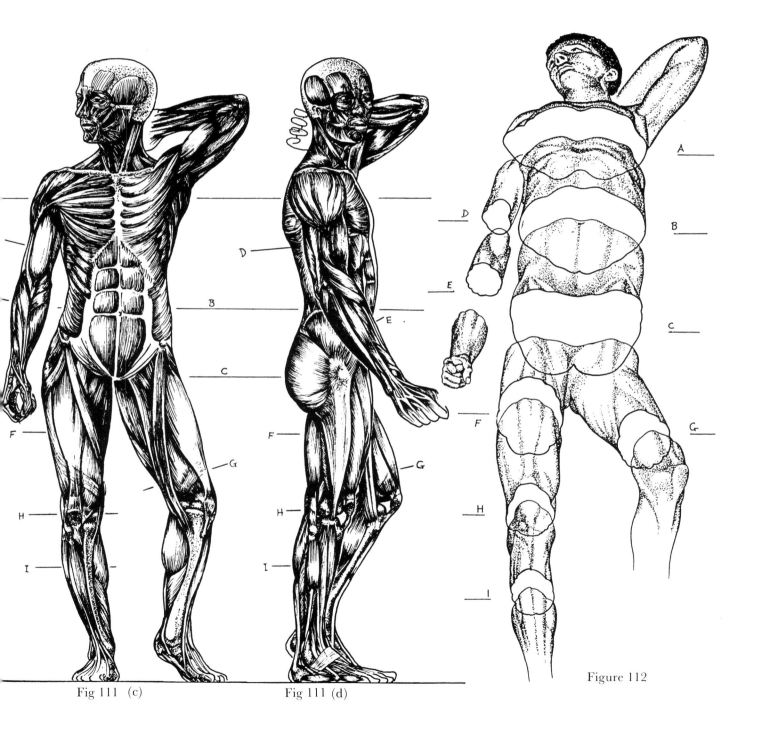

Fig 111 (c) Fig 111 (d) Figure 112

When you have completed drawings Fig 109 it would be wise to do as I have done, and draw in the skeleton, Fig 110, and anatomy, Fig 111, to further enhance your knowledge of the figure. I would advise making a clay model as in Figs 210–213, although I know from experience that many readers will feel that enough information is provided here, but it is in their interests to carry out the processes for themselves.

You should now have perfect drawings of your figure, which can be enlarged or reduced to fit the wood you intend to use. Two appropriate profiles can be traced on to the block following the principles previously explained, and the wood bandsawn resulting in the shape seen in Fig 113.

On a figure such as this, the accuracy of the drawings and bandsawing are of paramount importance. This is a simple figure and only a few areas of waste need removing before the modelling can start. It is essential that the bandsawn block and drawings are a perfect match, so that these areas can be easily located.

First, measure the dimensions of the profile view of the lower arm and draw the line on the block. Then repeat this operation for the front view of the arm.

This has been done in Fig 113. Fig 114 shows the same stage from the other side. It is clear that the extensions of the arm spread across the front of the body and back down the side. Therefore, the line on the torso must be measured and marked in down the back and down the right-hand side. By cutting in along the line of the right side of the arm and across from the right side of the body the front area of waste can be completely removed. Similarly, by cutting into the line of the back of the arm and the back of the torso, the waste behind the arm can be removed. Do this neatly and cleanly, cutting square into the corners with a flattish gouge (No.3) leaving a tidy tooled finish. The arm will now be free of the figure.

Figure 113

Figure 114

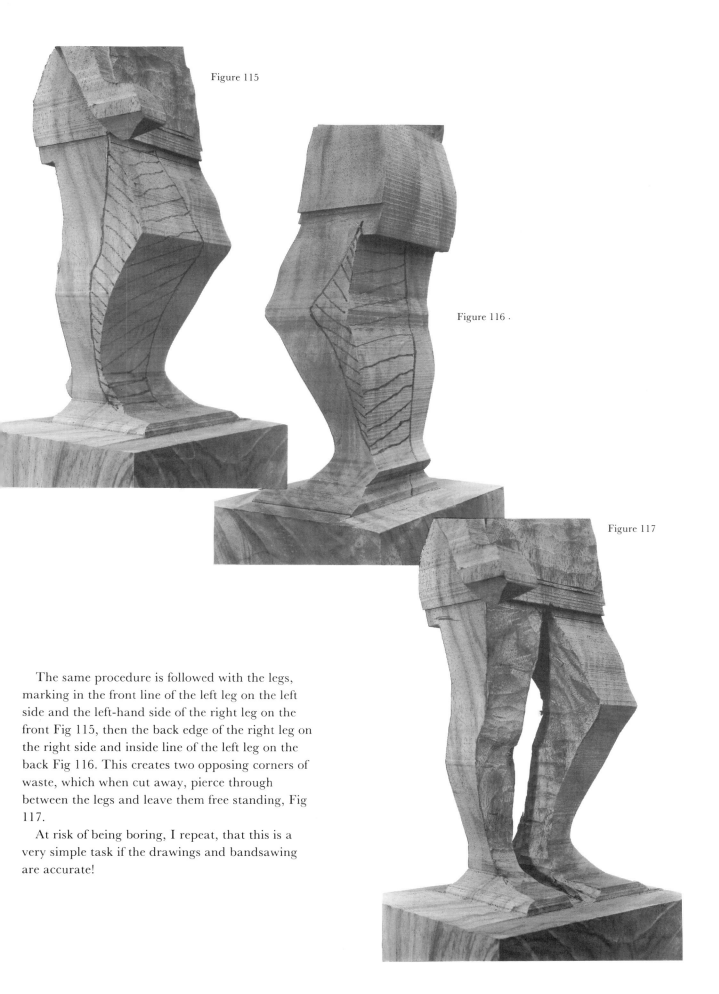

Figure 115

Figure 116 .

Figure 117

The same procedure is followed with the legs, marking in the front line of the left leg on the left side and the left-hand side of the right leg on the front Fig 115, then the back edge of the right leg on the right side and inside line of the left leg on the back Fig 116. This creates two opposing corners of waste, which when cut away, pierce through between the legs and leave them free standing, Fig 117.

At risk of being boring, I repeat, that this is a very simple task if the drawings and bandsawing are accurate!

Figure 118

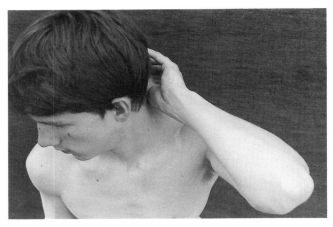

Figure 119 On the folded arm the muscles around the inside of the elbow joint are compressed and squeezed out at the sides. The bone running down the forearm, mentioned in Fig 111, runs from the large protuberance of the elbow, along the top of the arm in this picture, terminating at the lump protruding from the back of the wrist.

The other areas of waste are around the raised arm. This is not quite so straightforward. To digress a little, this is a typical case, as referred to earlier, where, because the limb projects at an angle from the body it is very difficult to draw an accurate projection of it from the front and side views. Therefore it is wise to leave a little extra bulk of wood to provide a margin of error. But it must be a known amount, decided on the drawings, not left arbitrarily by the bandsaw.

How, then, do we decide on the shape of the raised arm? We know where the elbow is, where the shoulder is and where the hand is. From the lower arm we can measure the lengths between these points. So, measure from the notch of the sternum out to the end of the collar bone where it articulates with the bone of the upper arm. This will be the same length on both shoulders. From this point measure the distance to the elbow making it the same for both arms. Now do the same from elbow to wrist. This gives you the basic dimensions. The arms are both the same thickness so you can start to rough out the shape as in Fig 118. In the process of removing the waste the head must also be re-orientated. The centre line of the face can be located from the drawings and the corners of the block rounded off accordingly.

The figure is now in a condition where all the constituent parts are isolated but still square. The next stage is to round everything off. This may seem a fairly facile statement but it is straightforward enough to turn the square sections

Figure 120

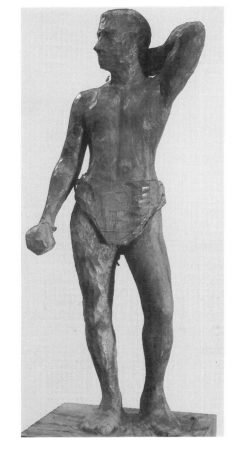

into cylindrical ones (see Figs 178 & 179 in the following chapter). This can be carried out with gouges or you may find it easier to use rasps and files. Certainly it is a good plan to use files to achieve a smooth finish on which to draw in the details Fig 120. We come now to a difficult stage of the carving, that is to draw all of the anatomical information on the diagram Fig 111 onto the body. The diagrams are not easy to comprehend but as you draw them on the body and see the way the front view connects with the side view you should begin to understand how the muscles fit together. Fig 122a shows the muscles of chest and stomach drawn and initialled. Compare these with the cross section Fig 112. Using a small gouge 6mm/¼″ No.9 incise the lines and then with a small flat gouge 6mm/¼″ No.2 round off the shapes of the muscles. Smooth them off with rifler files Fig 125. The form is shown more clearly in Fig 122b. Obviously, this will produce a kind of three dimensional anatomical figure (you could do worse than to make one for yourself) which will look over-muscled, but this can then be compared with photographs to what is actually visible on a particular person, Fig 121, and the muscles appropriately softened and smoothed down. The same process can be seen in the Jazz Dancer, Figs 216–219, a far more well-developed body. For figures that have little muscular development or are well covered in fat then the anatomy must be altered accordingly.

Figure 122a

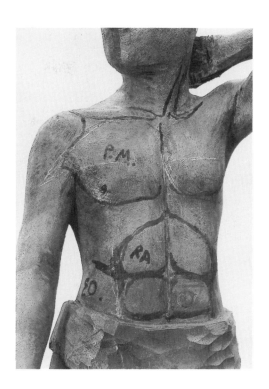

Figure 122b

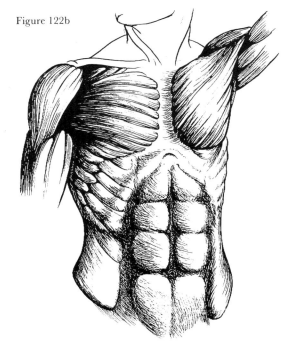

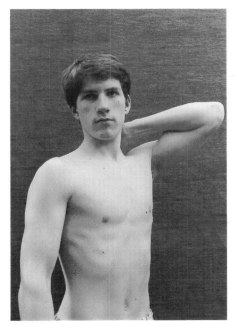

Figure 121, left. This shows another view of the raised arm. Note the highly contracted and swollen biceps and chest muscle (pectoralis major) pulled up to the shoulder. Compare this with the anatomy drawing Figs 122b, 124, 125 & 126 and with the back views, Figs 127, 128 & 129.

The muscle at the side of the neck, the sterno-mastoid, can clearly be seen and is indicated on the carving, as is the left-hand collar-bone. The pectoralis major muscles on the chest are somewhat under-developed and have been thickened on the carving, and the stomach muscles (rectus abdominus) have also been made rather more distinct. The shapes of the ribs are very subtle and need careful carving so as not to produce a skeletal effect, perhaps just ground in with a rifler file. The smaller overlapping muscles at the back of the ribs need similar treatment.

Figure 123

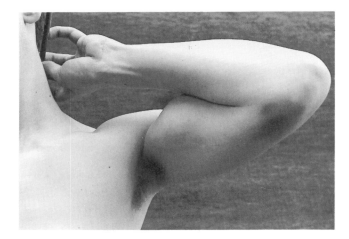

Figure 124

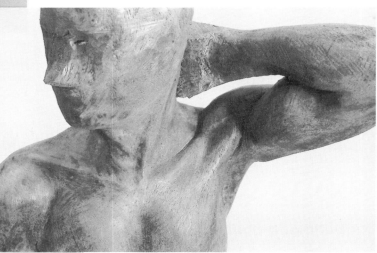

Figure 125

Figure 126

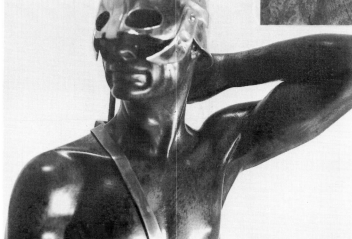

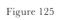

Fig 128 shows the shoulder muscles marked on the wood. The white marks are bones which are visible below the skin, in this case the spines of the shoulder blade and the vertebrae of the upper back. Fig 125 shows the front view of the same shoulder. Compare these tense, contracted muscles with the same ones on the other shoulder which are relaxed, longer and flatter, Fig 130 & 131.

Carving one part of the body runs into another part — it is difficult to do one piece in isolation. To complete the shoulder we must move onto the back,

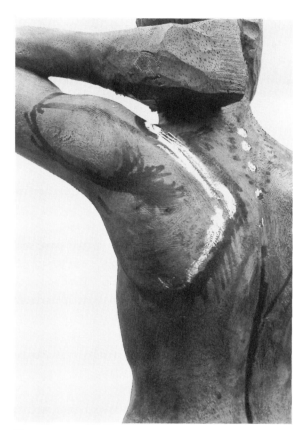

Figure 128

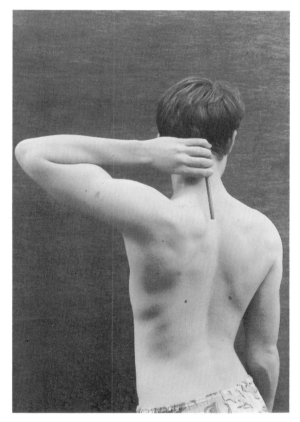

Figure 127

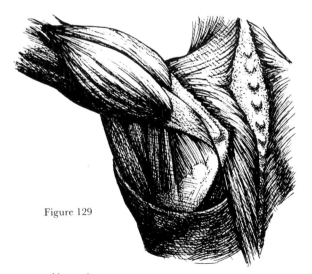

Figure 129

Figure 127, 128, 129 These pictures show the shoulder blade and arm as a working unit. The shoulder-blade is curved to slide across the ribs. When the arm is raised the shoulder-blade twists forwards and upwards — the lines of the inside edges of them can be clearly seen in Fig 127, they are marked in white on the carving, Fig 128 and dotted on the drawing, Fig 129. The deep cleft down the spine can also be seen, flattening out towards the bottom where the pelvis begins — compare with cross sections A B & C Fig 112.

perhaps the most complicated and difficult area of the body. The unfamiliar bones and muscles change dramatically with the movements and tensions of the body and careful study of the photographs and drawings is necessary. Needless to say any opportunity to study a live model should be seized upon.

The whole of the upper body should be completed in this way except for the hands which we will now consider in detail.

Hands are difficult: first, they are extremely complex and sensitive mechanical devices capable of a very wide range of movements, and secondly, they are probably the part of the body we are most familiar with and therefore able to criticise — plus, we attach great psychological significance to them. The 'body language' of hands, as with other parts of the body, is something which must be considered in the course of designing and executing carvings.

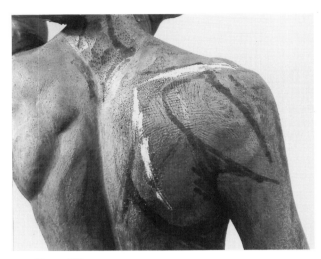

Figure 131

Figure 132

Figure 130

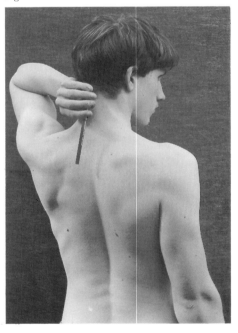

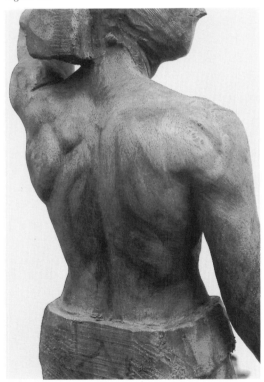

Figure 130, 131, 132, 133a & b In this view of the back the edge of the raised shoulder-blade is quite distinct, on the lowered relaxed arm far less so, except for the top edge, as marked on the carving, seen as a slight bump on the live model. On the raised arm a definite depression can be seen in the middle of the large muscle at the top of the arm (deltoid) — this is the division of the muscle which is in two parts, and shows when it is contracted. On the carving Fig 132, the muscles are not as complex and subtle as on the live model — that is something to aim for.

82

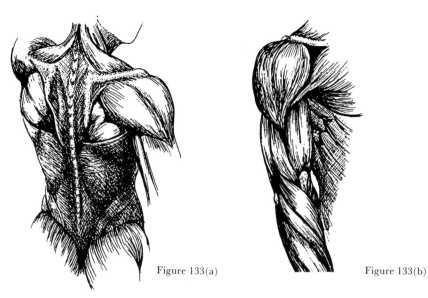

Figure 133(a)

Figure 133(b)

Figures 134, 135 & 136, below. These pictures clearly show how the muscles on the diagram are copied directly onto the rough arm and then incised with a small gouge. The side view must then be related to the front, back and inside views and the muscles connected. For example, the muscles twisting around the front of the elbow in 135 can be seen from the front in 133b and translated into wood in 136.

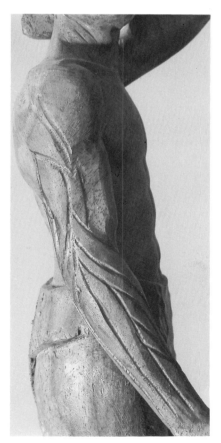

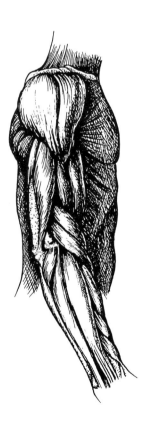

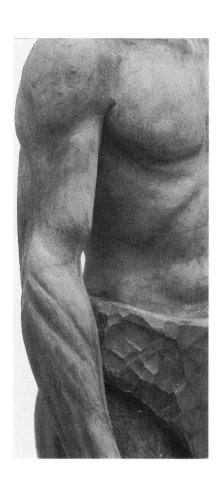

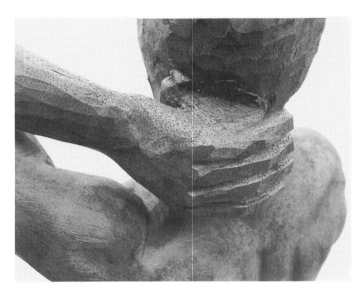

Figure 137

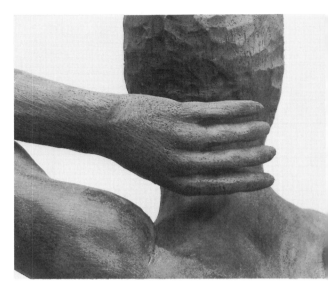

Figure 138

The anatomy of the hand is so complex that the illustrations in Fig 143 are not a great help, except perhaps, on the most sinewy, muscular examples. It is perhaps more helpful to reduce them to basic blocks and planes, Fig 142a b & c.

This shows more clearly how the basic shape of the hands can be carved, and relates directly to the first stage shown in Figs 137 & 141. Of course in this situation we have the added problem of releasing the hand from the head. In Fig 137 only the two main plains of the hand have been cut —

the flat back of the palm, the corner of the knuckles and curved plain of the fingers which have been divided into square sections similar to Fig 142a, using a small gouge or vee tool. Fig 141 shows this from another angle, and also the inside of the hand which is hollowed out, leaving the thumb. This can be done fairly easily with a rotary burr.

In Fig 138 the fingers have been divided using a fret or coping saw and roughly rounded off using a ribbon of abrasive cloth. (see Fig 191.) The subtler shapes of joints, etc., can also be modelled with

Figures 139 & 140 The problems of the hand are immediately apparent looking at the photographs. The range of movement of the fingers is so great and subtle that a slight error in the carving can result in failure. Thinking logically, we know that all the fingertips and thumb are touching the arrow and therefore give us a common factor. The slot for the arrow must be established at an early stage. By reducing the hand to square sections as in Fig 142, the problem can be made easier. Notice the distance between the knuckles on the back of the hand and the webbing between the fingers on the palm.

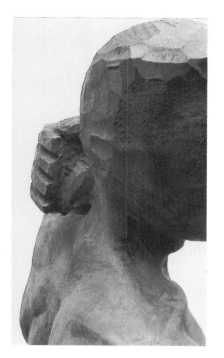

Figure 141

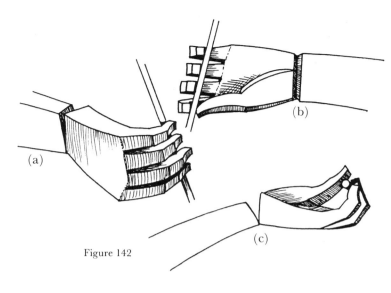

(a)

(b)

(c)

Figure 142

Figure 143 The muscles and skeleton of the hand.

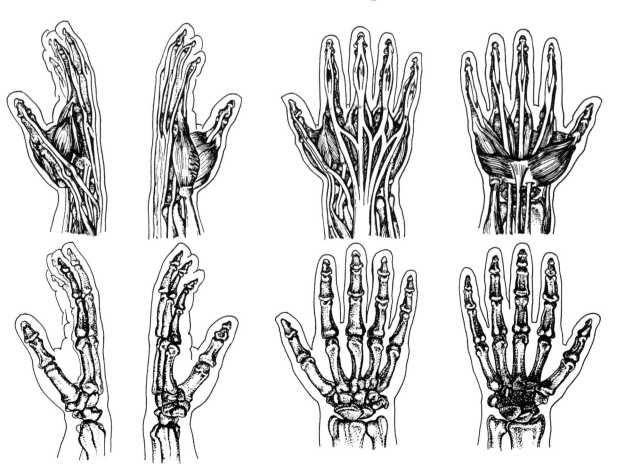

abrasive cloth, rifler files and gouges. Figs 144 &
145 show the left hand. Whilst still in its early
stages this hand must be drilled to hold the bow,
using first a 3mm/ ⅛ ″ drill to establish the line,
working up to a 6mm/¼″. The fingers are then
fitted round the holes.

Figure 144

Figure 145

Figures 144–149 Thinking of the fist as a squarish block, observe how the knuckles and first
joints of the fingers relate to the bow — almost in line with it. The forefinger usually
protrudes more because the thumb obstructs it from closing as much as the other fingers.
Notice, also, the angle of the thumb across the fingers.
The knuckles stand out very strongly, but the fingers are tightly squashed together. Careful
work with the knife is required to create these fine divisions.
In Fig 144 the hole for the bow has already been drilled. The principle is to drill the hole and
fit the fingers round the hole rather than trying to carve the hand and then drill the hole — a
recipe for disaster.

Figure 146

Figure 147

Figure 148

Figure 149

(a) (b)

Having completed the upper part of the body, the legs and feet can now be tackled, in the same way as the arms. Fig 150 shows the area around the hip joint, being the drawn circle, which can be felt as a large rounded bone. In Fig 152 the area below this is shown, with the calf and thigh muscles indicated, Fig 153 shows the front view. Compare these with the photos of the live model Fig 151a & b and the anatomy drawings Figs 151c–e.

To render the appearance of a rough pelt or animal skin, Fig 154, I used a rather blunt 6mm/¼″ burr at a fairly slow speed (12,000 rpm.) running it against the grain of the wood, which tears up the fibres rather than cutting them, leaving tufts of frayed wood which give a very similar appearance to rough fur.

Figure 150

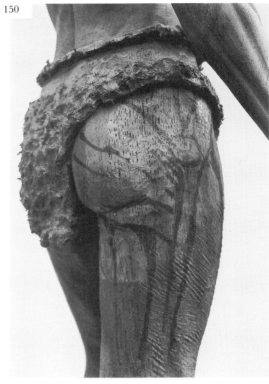

Figures 151a & b The area around the knee is complex and changeable according to the state of contraction of the muscles and bend of the leg. In Fig 151a the kneecap, on the supporting leg, is in the top half of the bulge, the lower half being muscle and sacs of fluid. Immediately the leg is bent, this lower bulge becomes a hollow as seen on the bent leg in Fig 151b.

(a)

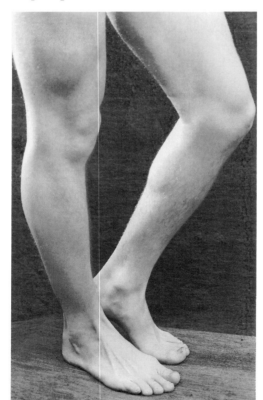

(b)

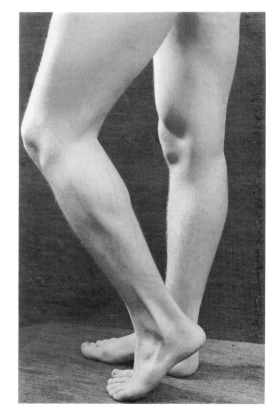

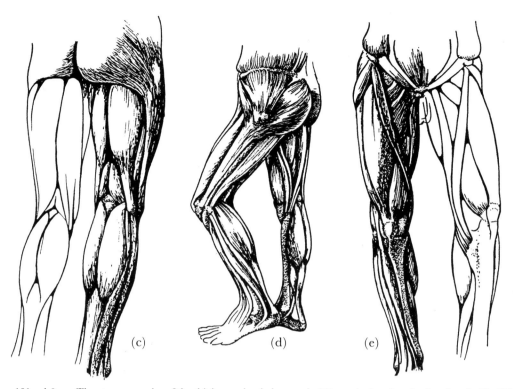

(c) (d) (e)

Figures 151c, d & e The strong muscles of the thigh can clearly be seen in 151a and related to the drawings in Fig 151e. The model has tensed the raised leg and this shows in the contracted calf muscle and stringy muscles running down the side. Notice the distinctive crease across the back of the knees in Fig 151b and their origin in the drawings, Figs 151c–e.

Figure 152 Figure 153 Figure 154

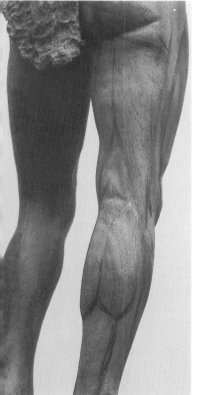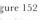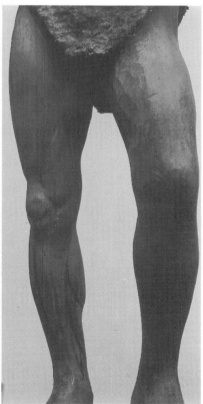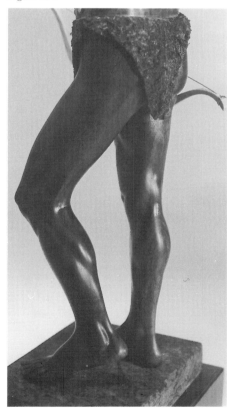

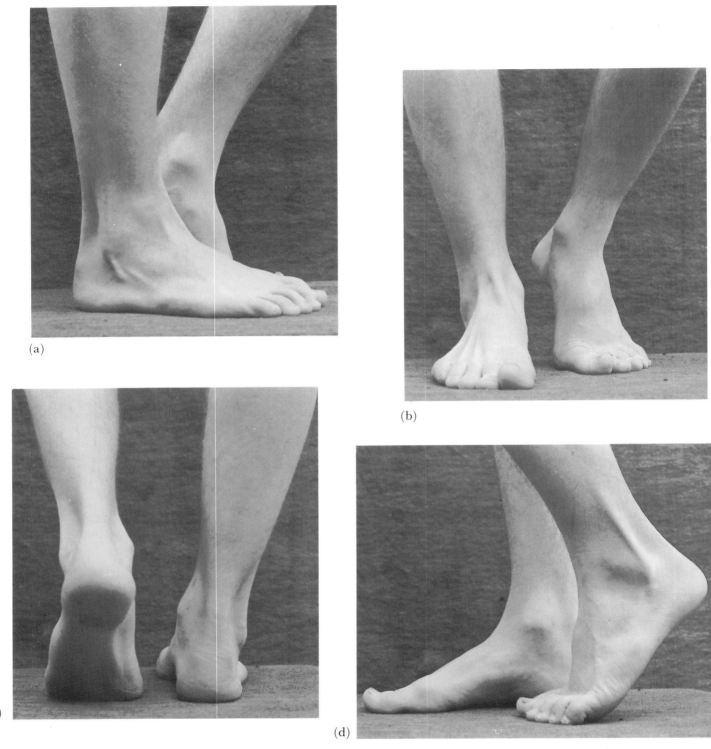

(a)

(b)

(c)

(d)

Figures 155a–d & 156a–d Feet are not very pretty in the flesh and it is easy to make them look hideous in a carving. Although they are a complex shape they do not have the variation of movement that hands have, and because of their lack of fat and muscle the anatomy is more easily discerned.

The tendons running down the ankle as shown in the anatomy drawings can easily be related to the photographs and the muscles running along the outer edge and instep can be clearly seen (the instep muscle in Fig 156d is contracted into an arch in 155d).

The heel-bone and attachment of the Achilles tendon can be observed in Figs 155a & 155c. Notice that the inside ankle-bone is slightly higher than the outside one also that the big toe turns upwards whilst the others turn down.

90

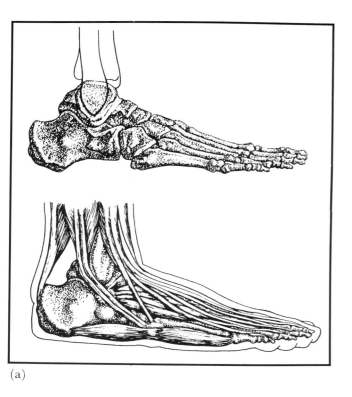

(a)

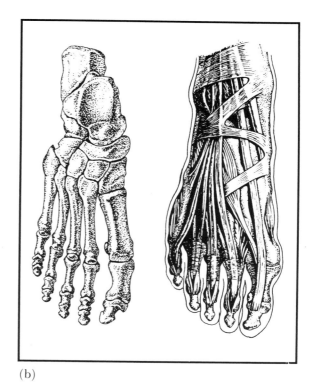

(b)

Figure 156

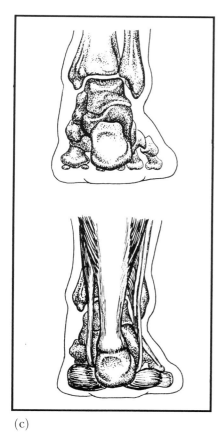

(c)

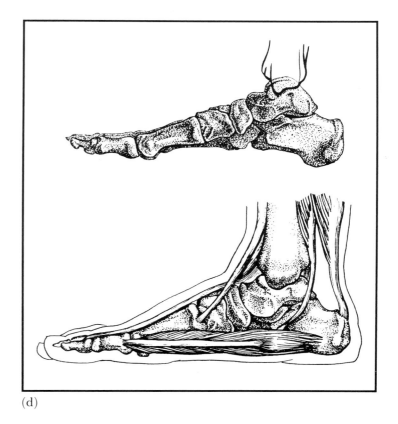

(d)

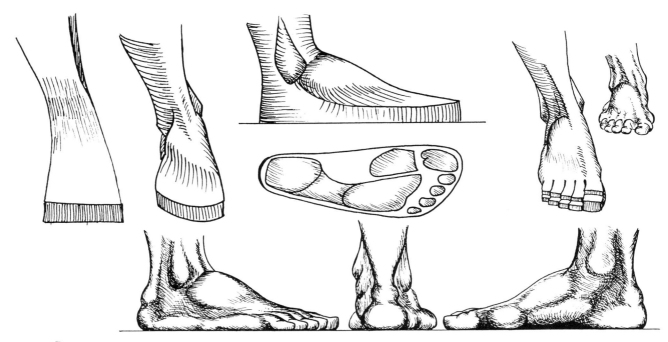

Figure 157 This shows a simplification of the carving process. The drawing from below shows the areas of the sole in contact with the floor.

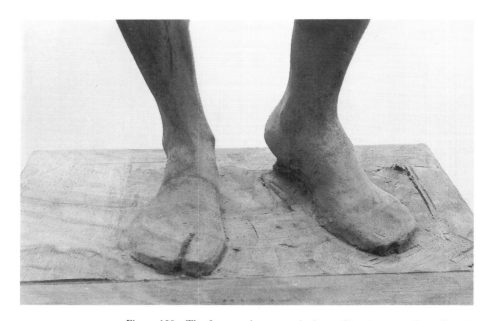

Figure 158 The feet are shown roughed out. Cleaning up and sanding the toes is surprisingly difficult, particularly if the figure is to remain attached to the base. When it is to be cut off, it is easier to finish them at that stage.

Carving Exercise for the Foot

This supplementary section follows similar guidelines as discussed for the exercise in carving the eyes. Figures 159 to 170 show twelve easy stages from the bandsawn block to the roughly finished carving. Consider this an exercise well worth the time and effort spent in perfecting the techniques and then try other poses for continued study.

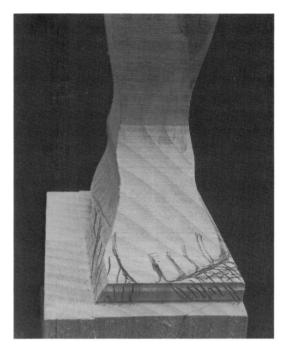

Figure 159

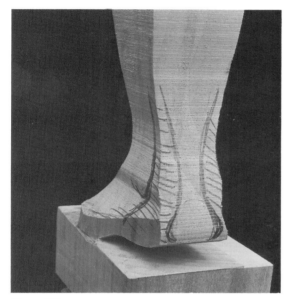

Figure 160

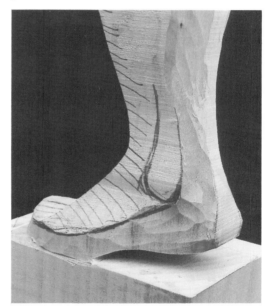

Figure 161

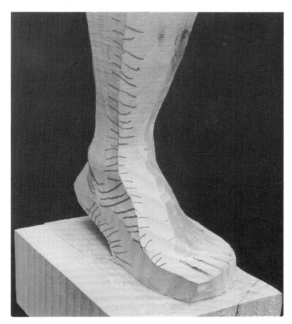

Figure 162

Fig 159 shows the bandsawn foot from the front with the first waste area to be cut away marked in. Having done that we then turn to the heel, Fig 160, and cut the thin area either side of the Achilles tendon and the ankle-bones. Fig 161 shows this completed and the front surface of the foot and leg marked ready to round off, as in Fig 162.

93

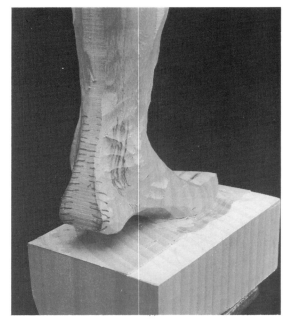

Figure 163

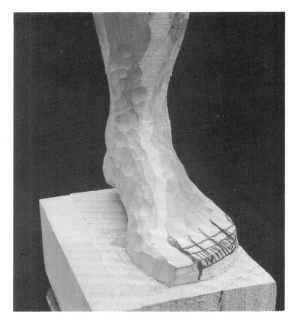

Figure 164

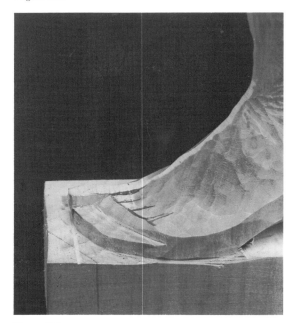

Figure 165

Continue rounding off the front of the foot and leg and then scoop out the instep. Fig 163 shows the heel ready to be rounded and the area behind the ankle-bone to be hollowed slightly. The basic shape of the foot has now been established and work can commence on the toes. Fig 164 shows them marked ready for cutting into stepped shape, and completed in Fig 165. This shape can then be divided into the individual toes, Fig 166.

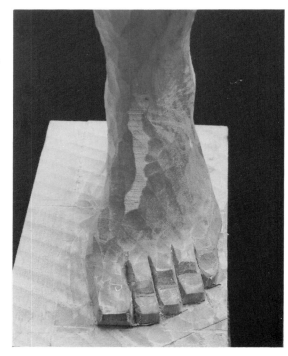

Figure 166

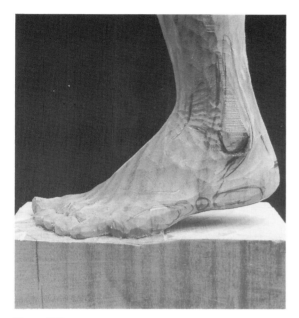

Figure 167

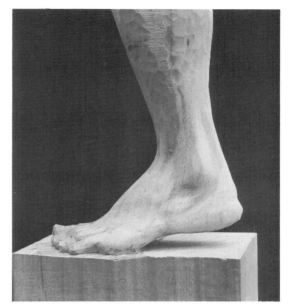

Figure 168

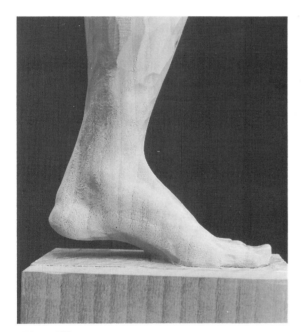

Figure 169

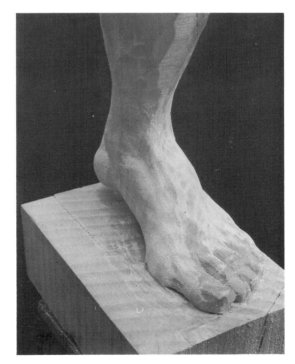

The toes are then rounded and shaped, Fig 167. Further refinement of the structures in the foot can then be completed using the anatomical drawings and photographs as a guide. Figs 168 to 170 show the foot completed and in the process of being rough sanded. The toe nails are carved in the same way as finger nails (see Figs 192–194).

Figure 170

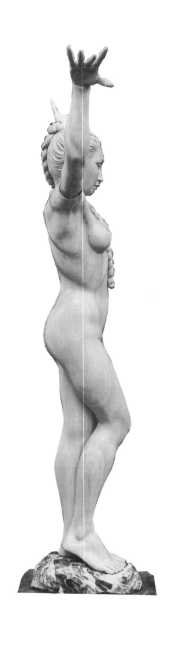

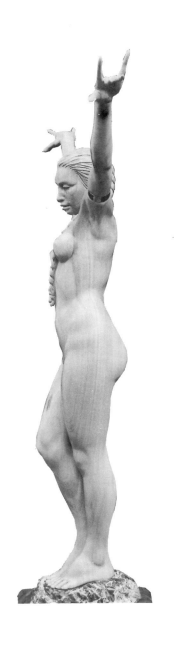

CHAPTER TEN

The Fema

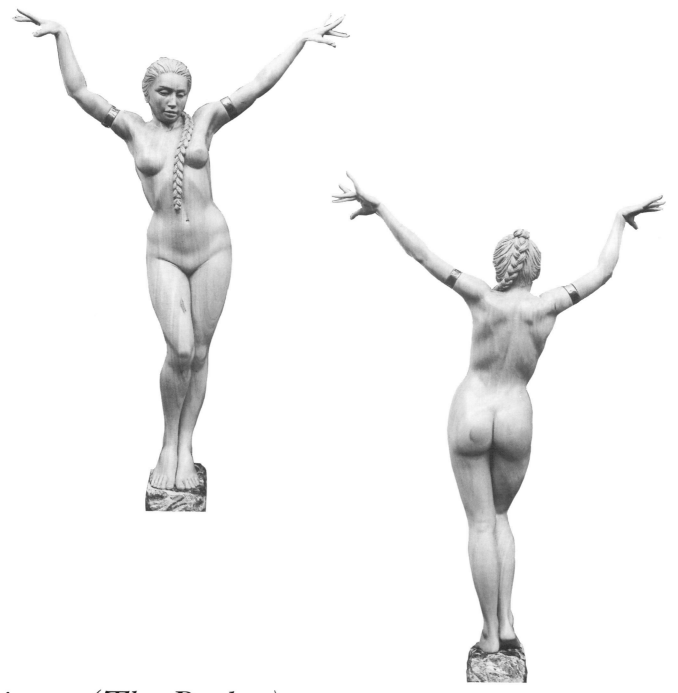

igure (The Bather)

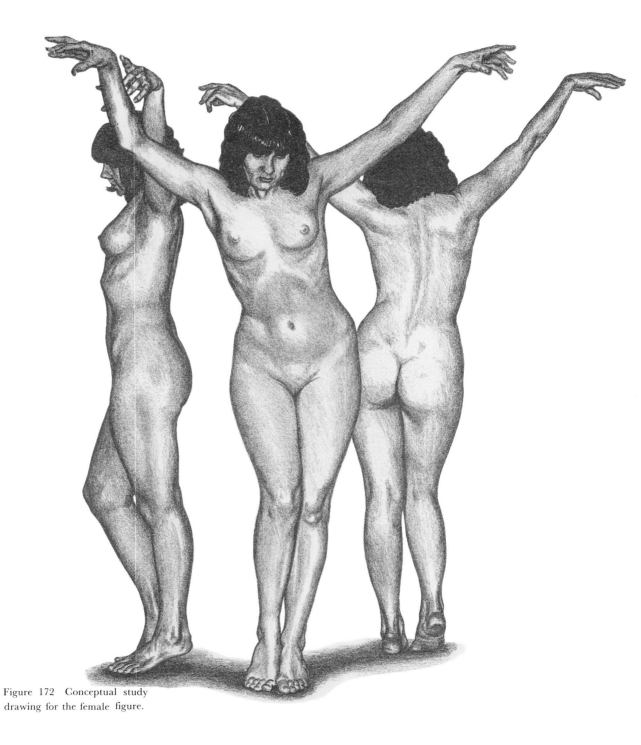

Figure 172 Conceptual study
drawing for the female figure.

98

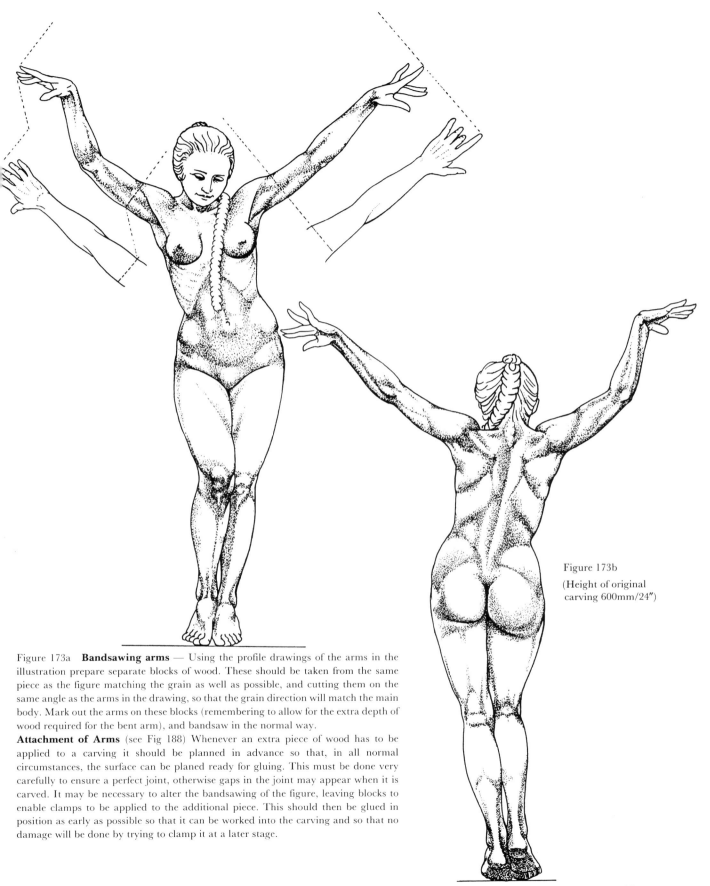

Figure 173a **Bandsawing arms** — Using the profile drawings of the arms in the illustration prepare separate blocks of wood. These should be taken from the same piece as the figure matching the grain as well as possible, and cutting them on the same angle as the arms in the drawing, so that the grain direction will match the main body. Mark out the arms on these blocks (remembering to allow for the extra depth of wood required for the bent arm), and bandsaw in the normal way.

Attachment of Arms (see Fig 188) Whenever an extra piece of wood has to be applied to a carving it should be planned in advance so that, in all normal circumstances, the surface can be planed ready for gluing. This must be done very carefully to ensure a perfect joint, otherwise gaps in the joint may appear when it is carved. It may be necessary to alter the bandsawing of the figure, leaving blocks to enable clamps to be applied to the additional piece. This should then be glued in position as early as possible so that it can be worked into the carving and so that no damage will be done by trying to clamp it at a later stage.

Figure 173b
(Height of original
carving 600mm/24")

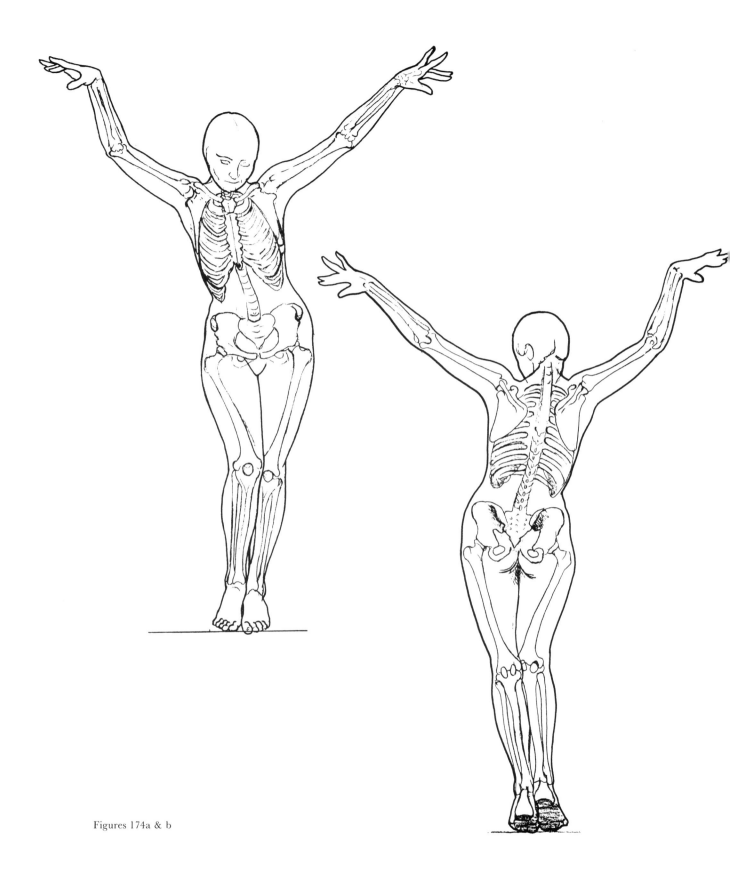

Figures 174a & b

Figure 175a

Figure 175b

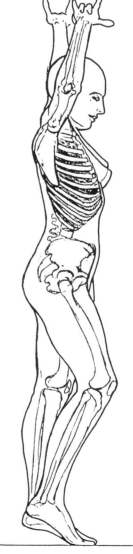

Figure 175c

Figures 175a & b The dotted line from the raised heel to the base indicates the line to be bandsawn in order to strengthen this area during carving. A similar method is employed on the Jazz Dancer.

THE carving process here is exactly the same as in
the previous example, if anything more simple
because the arms are more straightforward. Fig 176
& 177 show the main waste areas to be removed
from front and back. Although the ankles are thin,
no heavy mallet work should be involved in this
figure, so the strength of the support should not be
a problem (the dotted line from the heel in Figs
175a & 175b indicate where the figure should be
bandsawn to support the heels).

Figs 178 & 179 show one half of the figure
roughed out, the main forms indicated — the
shoulder blade structure, the buttock, the hip and
the breast and belly begin to appear.

Figures 176 & 177 The bandsawn figure ready for carving.

Figure 178

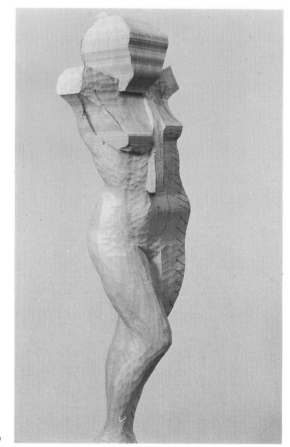

Figure 179

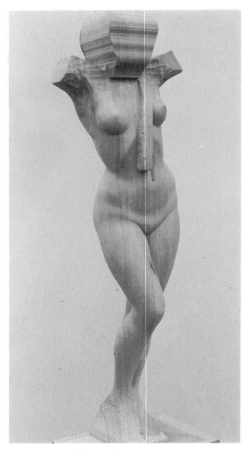

Figure 180

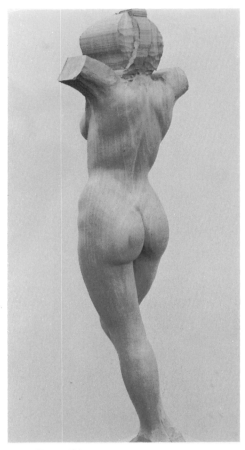

Figure 181

Figure 182 The female pelvis (right) is wider than the male's and creates a different pattern of shapes on the back.

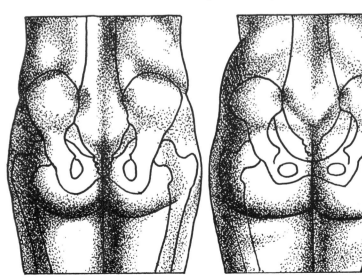

Continue as with the male figure but do not incise the muscle shapes as sharply or the result will be an over-anatomized lady weight-lifter — of course you may want that. Once shapes have been cut in, it is difficult to get rid of them. The form I have made is indicated on the drawings Figs 173a & b, 175 a–c, and can be observed in the photos of the carving and the live model. The idea is to produce a soft female form, based on a knowledge of what lies underneath but not overtly displaying it. Bruno Lucchesi, in his book, 'Modelling the Human Form in Clay' does this in reverse by making the anatomical figure first and then literally clothing it with a skin of clay. Ideally, the subtler muscles should show when the light catches them the right way. Figs 180 & 181 show the main figure rough sanded.

In Figs 183 & 184 we are tackling the
more difficult area of the head, neck and
shoulders. Orientation of the head is again very
important and the lines drawn on the rounded
block indicate how this is achieved. Great care
must be taken at this stage since there is very little
room for error — should a mistake occur it may be
wise to accept the realignment of the head rather
than having to remove more wood to correct it. Figs
186 & 187 show the face modelled and rough
sanded, still left very soft and featureless, leaving
the option of cutting in details until the basic shape
is perfect.

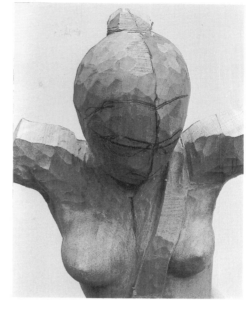

Figure 183

Figure 184

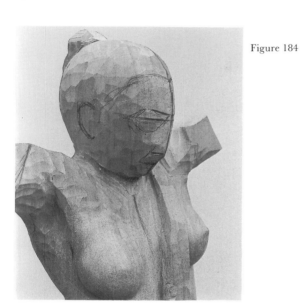

Figure 185

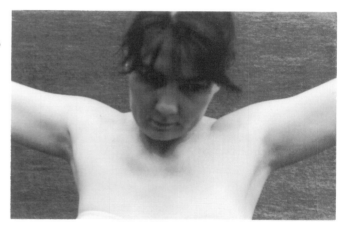

Figure 186

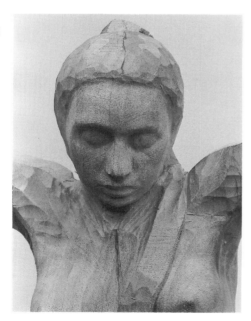

Figure 187

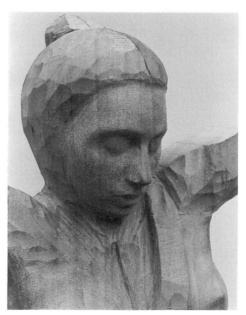

105

The Arms

The arms can now be temporarily fixed in place with instant glue and shaped down to the hands, then removed cutting through the glue line with a fine saw, and held in a vice to carve the hands, Figs 188 & 190. The structure of the hands has been covered in some detail in the previous chapter, but these are considerably different. Although more delicate they are more accessible and open. Fig 190 shows the waste being removed with a knife, using the thumb to balance the pressure. When the shape is roughed out, the divisions between the fingers are cut with a fret saw. The modelling is then continued almost entirely with rotary burrs and, more important, abrasive cloth strips, as shown in Fig 191. Great refinement of shape can be achieved using carefully cut strips of different grades. The completed hands can be seen in Figs 194 & 195.

Figure 188

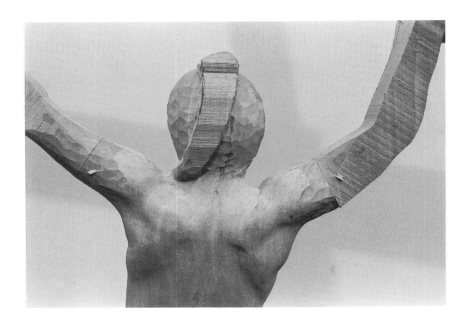

Figure 189

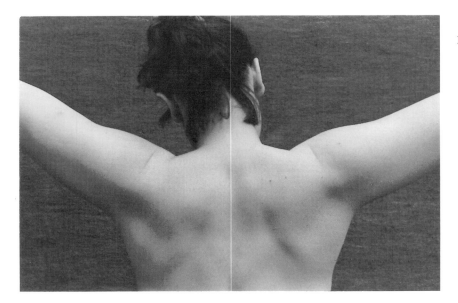

Figure 190

Figure 191

Figures 192 & 193 A small vee tool is used to cut in the sides of the nail and a gouge of suitable curvature to cut in the cuticle. The nail is the pared down, sloping into the finger as it goes. This is then carefully sanded, Fig 194. Although there are strong creases on the fingers, Fig 196, I personally leave them out on the female.

Figure 194

Figure 195

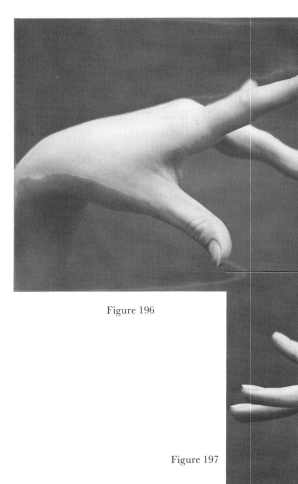

Figure 196

Figure 197

Figure 198

108

Fig 199 shows the completed arms again glued in position. The shoulders have been finished to blend with the arms and recesses cut to accept copper rings which will cover the joints. The recesses are marked out using strips of adhesive tape, and cut in with a knife, the same strips then being used to mark the copper tubing. The arms are then removed again using a fine saw and the recesses adjusted to fit the rings of copper tube. This may need enlarging by tapping with a hammer on a round mandrel. Remember that the arm would compress to fit the circular bracelet, so the edges of the recesses must be rounded appropriately. Figs 200 & 201. If metal rings are to be fitted around the arms then the joints will be concealed and supported and do not need to be particularly strong. Epoxy resin glue could be used. If, however, you choose not to have the metal rings then the final joint must be very good, perhaps even dowelled, and will probably show, especially on limewood, although not as much on a grainy wood such as walnut.

Figure 199

Figure 201

Figure 200

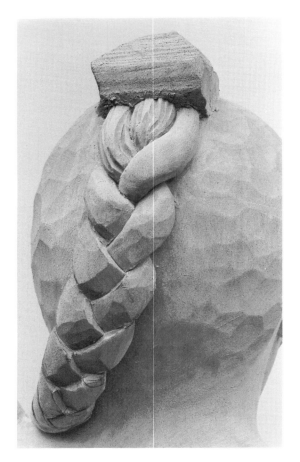

Figure 202

The hair, dealt with in detail in Figs 96 to 101, is fairly simple on this figure. The plait is tricky, delicate work but the form is straightforward, Fig 202. Notice that the individual hanks of hair are carved to a perfect shape and rough sanded before the strands are cut in with small gouges. Fig 203 shows the finished top-knot with a small stone set in it — optional, of course.

When the figure is completely carved and sanded, except for the feet, these details can now be undertaken, Figs 204–206. Great care must be taken to cut through between the legs and ankles which fit together closely. It may appear that there is simply not enough wood, but it will work out if the measuring is done carefully and the cutting is accurate. It is best done with a knife, slicing between the limbs. When the feet are carved on the upper surface (see Fig 155–170), as far as can be done, cut the figure free from the base and carve the soles of the feet, using burrs and knives, holding the figure by hand, resting the body on a cushion.

Sanding is crucial, as always, but in this case more than ever. Using 120 grit sand the figure until every detail is softened, almost to extinction, then working on through the grades to 240. Seal and rub down with 400. Look for any harsh or sharp lines, for example the lines of the rib-cage and armpit on the finished figure are a trifle strong.

Figure 203

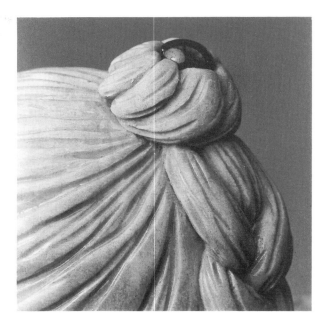

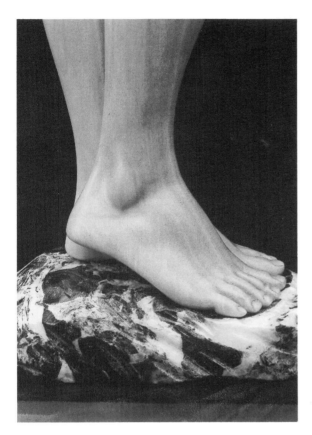

Figure 204

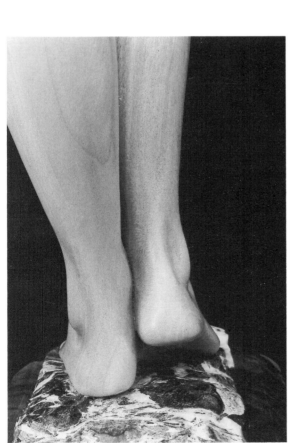

Figure 206

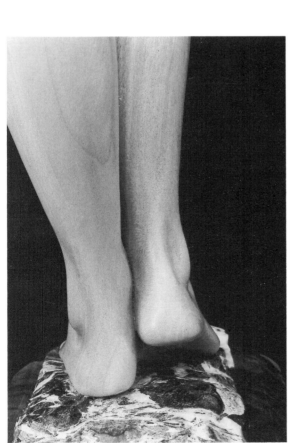

Figure 205

111

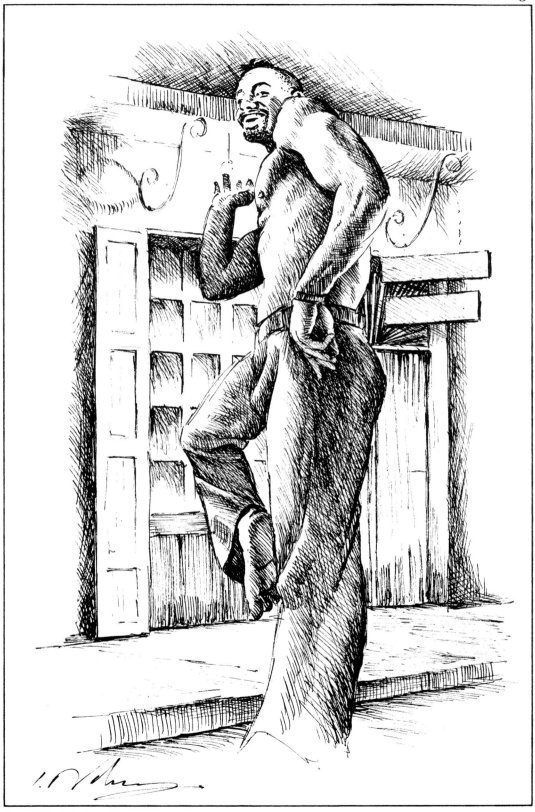

Figure 207 The Jazz Dancer

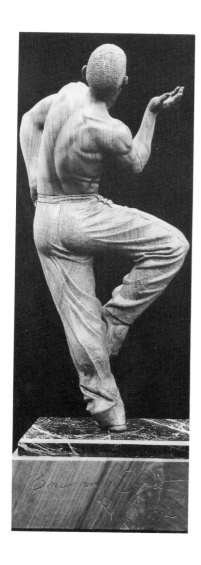

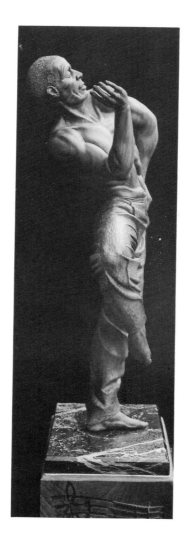

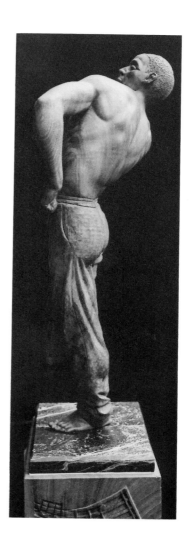

Figure 208

Jazz Dancer

THE aims of this project are two-fold: first to create a carving from a picture which provides insufficient reference material in itself and which is too complex or ambiguous to make up from other reference material, ie. other photos, anatomical pictures etc. Also it is assumed that the subject of the picture cannot be called upon to pose again. In this particular case, I saw a street entertainer dancing in New Orleans. Although I took a picture of him it was pretty well useless. At a later date I came across another picture which embodied much of what interested me in the dancer. The illustration Fig 207 is my drawing with reference to this photograph.

The second aim is to provide a basic understanding of carving clothing. This can be boring and difficult if tackled superficially, but if it is carefully analysed and used to enhance the figure it can be a very interesting and rewarding aspect of figure carving. One cannot always be carving nudes and there is great scope for studying the effects of different fabrics and the way they fold or hang to reveal the lines on the body underneath. Indeed the soft baggy trousers on the dancer are a case in point where only small areas reveal the underlying figure — the knee and thigh, the hip and so on, yet quite obviously there is a pair of legs inside them. We must show this in the carving.

Having only my drawing, the obvious thing to do was to find someone to pose in the same position. This I did, but found that because the figure is in mid-movement of a dance, the pose is very difficult to adapt and maintain. A professional might well be able to, but the average person does not have the loose fluid movement and balance to even get into this position. The photographs I took were of little

use. I then decided to use an artist's lay figure or mannequin, Fig 209 — the small articulated wooden figures available from art shops. Even the mannequin would not take up this posture without my making considerable alterations to it to enable the raised left leg to swing out sideways and the shoulder to hunch upwards.

However, having eventually forced it into a fair approximation of the pose as seen from the front, it then gives you a reasonable idea of the shape of the figure seen from other angles. Using this as a starting point, I set about making a clay model.

The first step is to make a metal armature to support the clay. I used a piece of steel rod about 6mm/¼″ thick as the main pillar, Fig 210. I cut the rod to the same length as the figure in my drawing, about 350mm/14″, and bent it to follow a line down the middle of the head and torso, and then down the supporting leg to the front. Then, using the mannequin as a guide I bent it the other way, following a line down the spine and again down the supporting leg. I arched the spine back slightly more than the mannequin showed, to give a little more movement to the figure. The support for the arms and raised leg are made from thinner wire, about 3mm/ ⅛″.

Measure from the top of the head to the top of the breastbone where the collar bones meet. Twist a length of wire tightly round this point leaving about 300mm/12″ free at either side. It is difficult to make these joints firm so I usually reinforce them with a resin car body filler. I also smear it along the rods to help the clay adhere. Now take measurements of the length of the collar-bones from the anatomical drawing Fig 110, and make a sharp bend at the appropriate points in the wire. Repeat

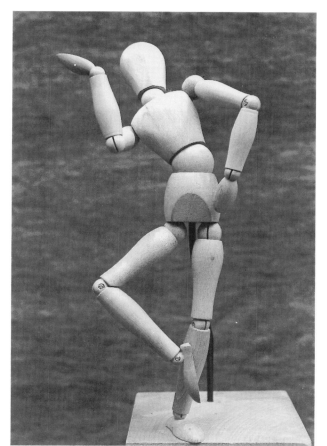

Figure 209

Figure 210

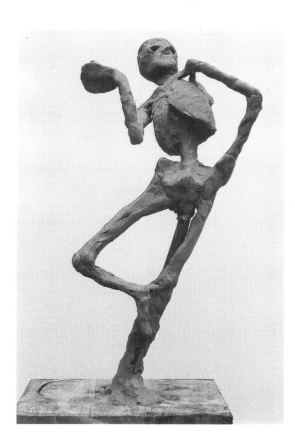

Figure 211

115

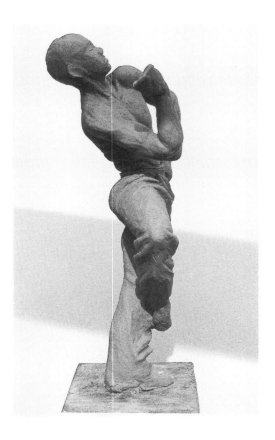

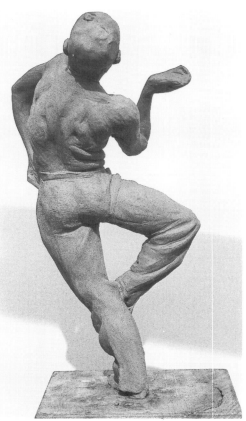

this for the elbows and wrists. The raised arm must be free standing but the other can be extended and attached to the steel bar at the appropriate point. All measurements should be taken from the anatomical drawings and related to the angles and position of the figure drawing. Do the same with the raised leg. It is difficult to get the armature right and mine was not exactly what I wanted, but it is not for copying slavishly, only a guide to making the working drawings.

We can now put some very rudimentary bones onto the armature Fig 211. Study the photograph, the mannequin and the skeletal illustrations in Fig 110 very carefully. Since the right shoulder is hunched forward so much the rib-cage, which is a rigid box, must be turned somewhat in the same direction, so a roughly shaped rib-cage can be put in place. The position of the skull can also be judged from the drawing and placed on the top end of the armature. The pelvis is about square on to the front but tilted slightly from left to right. By a process of observation and deduction the skeleton can be assembled.

Now we can apply the muscles to the skeleton. There are two ways of doing this: by carefully building the muscles from pieces of clay or by quickly adding a good bulk of clay and then cutting it away to shape the muscles. I normally use the second method although the former is probably more instructive in anatomy, Figs 212 & 213.

Making a clay model is not easy, but if you look at the body like a machine, then there are a limited number of variables. Use the length of the bones and their limited capacity to move as a blueprint. Adding the muscles requires patience and careful study of the anatomy, but in real terms we are probably talking of three day's work at the most on the model (mine took me one day including the armature) which is not a lot for a carving which would certainly take me three weeks. Although your model may not be anywhere near correct, if the basic dimensions are accurate, then at least the pose is good enough for the working drawings to be bandsawn. Then, using your original picture you can work round the body from the known facts that you have. That is, after all, pretty much the way

Figures 212 & 213 The clay model

Michelangelo worked, as can be seen from his half finished sculptures, literally starting at the front and working around the figure into the block.

When you are satisfied with the clay model you have two choices — photograph it as if it were a live model and carry on as in earlier projects, or draw it by careful measurement. Not everyone can draw and photography is really the best method, and if time is money, it is more economical.

From now on the carving follows the same procedure as the two preceding ones, apart from the clothing. Figs 214 & 215 show the first stages of roughing out.

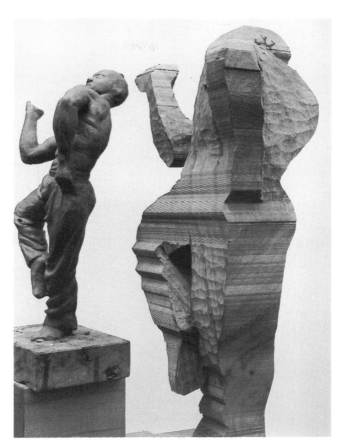

Figures 214 & 215

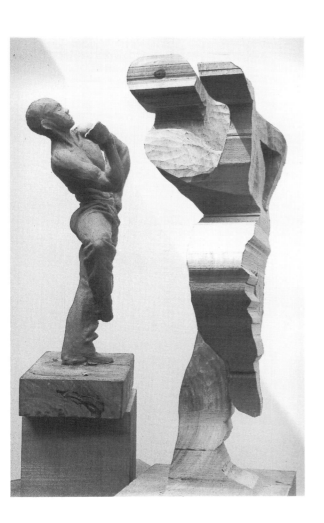

Figure 216

Figure 217

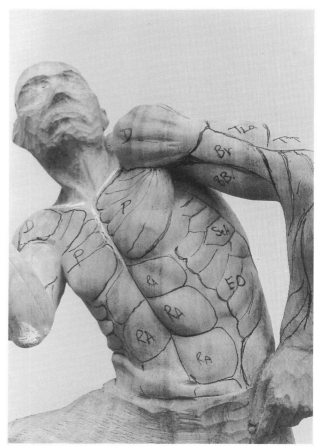

Figure 218

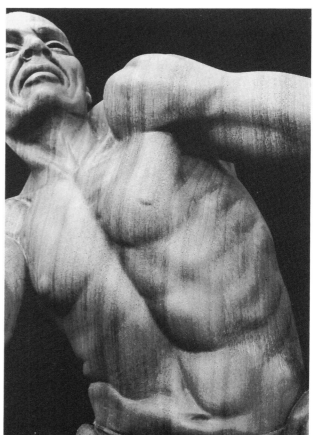

Figures 216–219 The highly developed physique of this model displays some of the features not always seen. The divisions of the pectoralis muscles on the chest can be detected in Fig 216 and those of the deltoid on the shoulder in Figure 219. Notice how the bottom of the ribs on the left side fold into the top of the pelvis.

Figure 219

Figures 220–221 The muscles on a well-developed back are extremely complex and change dramatically with relatively small movements of the body. The shoulder blade structures are less distinct being more buried in muscle.

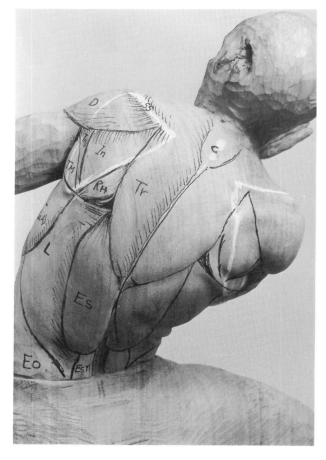

120

Figures 222–223 The deep cleft of the back formed by columns of muscle rising up from the pelvis can be clearly seen. The trapezius (Tr of Fig 221) are also quite distinct.

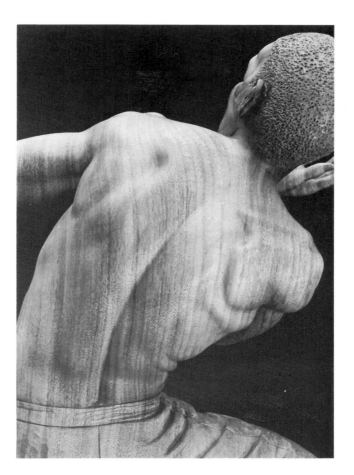

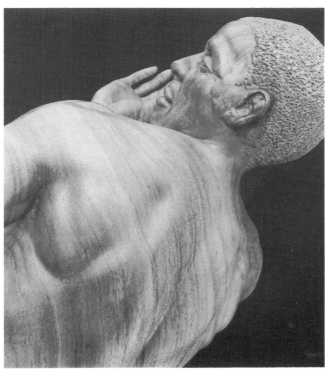

Figures 224a & b These photographs show the massive
muscles of the shoulders and neck and the highly developed
deltoid at the top of the arm. The highlight on the photo-
graph running across the shoulder into the muscle indicates
the top edge of the shoulder-blade, which locates with the
outer end of the collar-bone, seen as a small lump in the
deep hollow above the joint.
In Fig 224b the treatment of the hair can be seen to be
numerous holes drilled with small rotary burrs.

Figure 224a

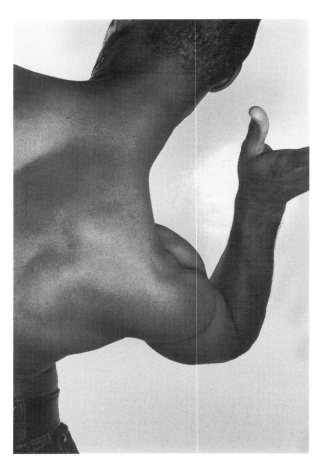

Figure 224b

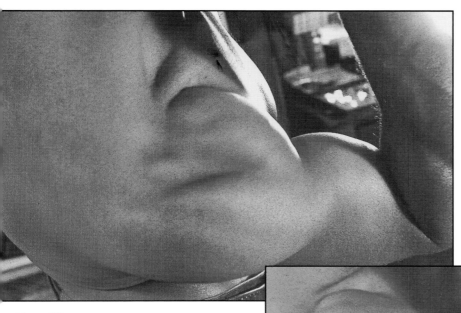

Figure 225a

Figure 225b

Figure 225c

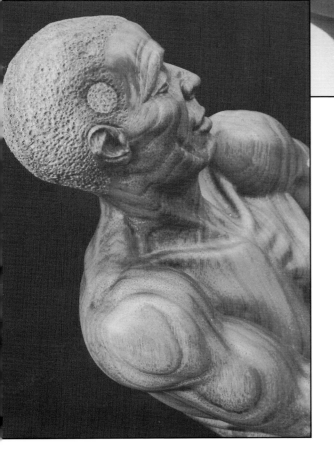

Figures 225a b & c Another view of this difficult area showing heavily contracted muscles. The collar-bone can be seen on both photographs terminating in a small bump.

The circular spot on the head in Fig 225c was a dead knot, drilled out and plugged with wood, subsequently stained.

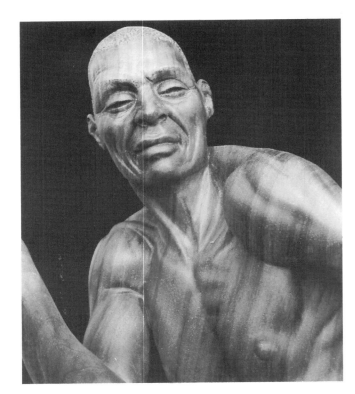

Figure 226

Figure 227 This view from above shows the orientation of the body and is in the same alignment as the working drawings Figs 229a–d. It also shows the forward hunching of the right shoulder seen in Fig 226.

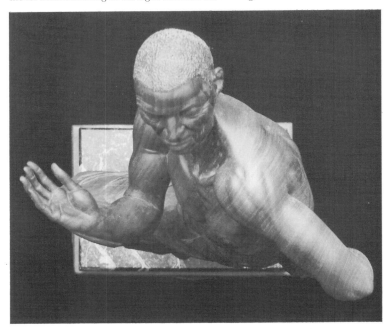

Carving the trousers

Figures 228a–d These photographs are not those actually used for the original drawings and carving, but they illustrate the principles involved. Notice that although a different model, the areas in contact with the body underneath the clothing are very close to the drawings indeed. I would suggest that in carving this project the reader uses these photos as a model, and the drawings for reference.

(a)

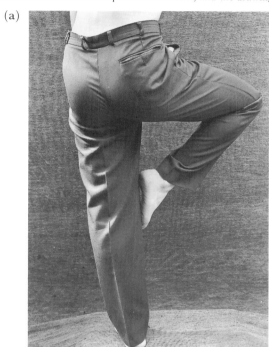

(b)

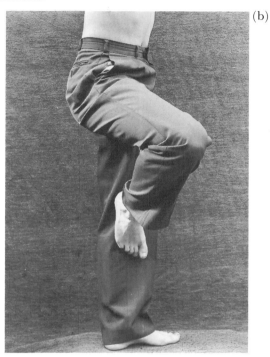

(c)

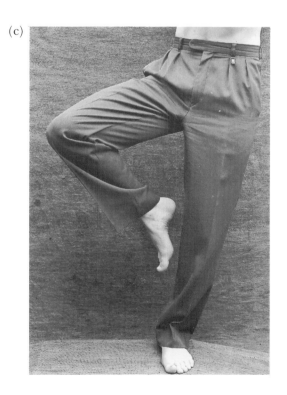

(d)

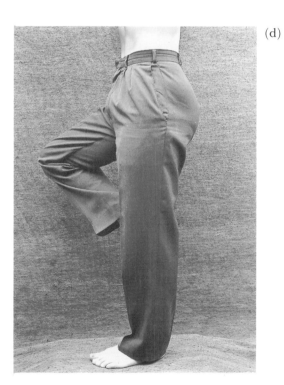

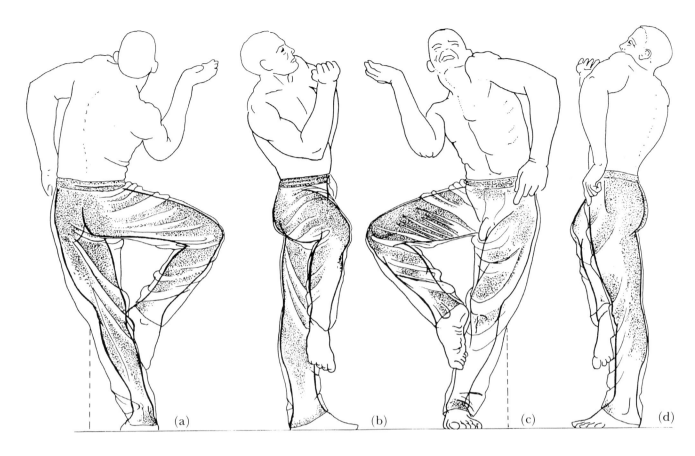

Figures 229a–d Working drawings. Notice that the broken lines in (a) and (c) indicate the line to be bandsawn in order to give support to the leg in the early stages of the carving.

Folds

The dancer's trousers are quite loose and baggy, nevertheless, the size of the unworked legs on the carving appears very large. What we have to do is to cut away the wood in the areas where the cloth is closer or in contact with the actual leg. These areas are dotted in the drawings Fig 229a–d.

This can clearly be seen on the buttocks and the top of the raised thigh and knee. It is less obvious on the supporting hip and inside calf and thigh, and on the raised calf and ankle. Also in the hollows of many of the folds the cloth is very close to the leg. If these points are not brought out the trousers become empty bags.

Study the pattern of the folds and creases on the four views in Fig 229. Notice how they radiate from

points of tension such as the bent knee and the crotch, in contrast to the heavy collapsing type on the supporting leg, and the deeply creased puffiness round the bent hip. Notice too, that there is a system to folds in cloth. Unlike skin it does not fit all the time; there is a certain amount of material and it must go somewhere. One rarely finds a fold in isolation — there is always a counter fold, and another, and another.

This creates a considerable technical problem and one which has occupied artists for generations. Drapery can be simplified and stylized to a certain extent, but it always requires a lot of hard work. Deep, narrow cutting is required to get the effect of deep heavy folds and careful study of the underlying shapes to achieve the appearance of solidity within.

The creases in the trousers, and the seams and pleats, have a considerable effect on the folds. This can be seen on the sides of the raised thigh where the fine tight folds tend to stop at the seam and on the supporting leg and where the creases run through all the folds, Figs 228 & 230. Most of the folds have a bias one way or the other. This seems to be fairly arbitrary, but a group of folds tends to follow the same bias.

Rough in the shape of the folds cutting along the valleys with a 6mm/¼″ No.11, paring down the flatter areas with a 6mm/¼″ No.5. Use all the four views, Figs 228 & 229 to follow the creases around the legs. Smaller gouges will obviously be required for the tighter folds and to scoop out the 'eyes' of the folds. Knife work will be needed to make the really deep sharp valleys. Work over the whole of both legs to get a complete pattern, gradually refining the carving, being careful to bring out the areas where the leg shows through, Fig 231.

At this point it will be necessary to separate the raised foot from the supporting leg. Also remember that the supporting foot was not accurately bandsawn and this must be rectified (see Fig 229).

The tooling of the trousers is an option which you must decide on. Tooling — that is the final carved finish created with very fine, clean gouge cuts over the whole area — is difficult and time consuming, as is sanding. If you wish to use the tooled finish you will need a wide variety of very sharp gouges to fit all the curves and hollows, carefully making thin clean cuts of an even size and curvature. When the work is finished you will find, in different lights, bad cuts, tears, and snags which do not sit well on the eye and these must be recut. It requires patience and perseverance. Different sized tool cuts will create different textures, suitable for different fabrics, which of course fold differently as well.

Figure 230

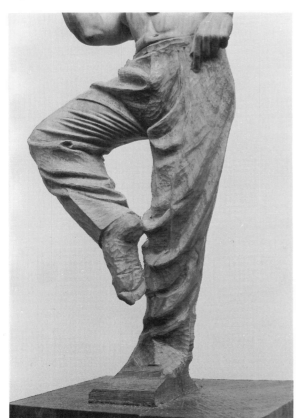

Figure 231

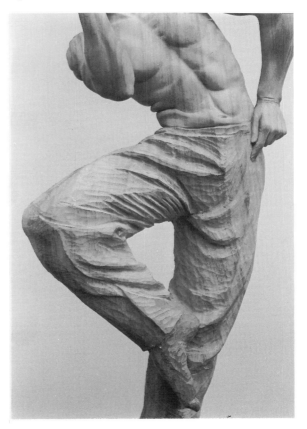

CHAPTER TWELVE

Creating your own Figure

HAVING spent many hours, weeks even, drawing the anatomical studies for this book, having carved dozens of figures, drawn and painted hundreds, spent hours in life classes, made clay models, and generally studied the human body more closely than the average person would believe, I am relatively ignorant of its anatomy. Every time I do a carving or look at a body, I find new bits that I had not noticed — or are more developed or prominent on the particular person, and, more important, I find I want a slightly different emphasis for a particular figure — more or less boney, taller, fatter, or more muscular. I must confess, I have never studied, in the flesh, a grossly fat person, and would be in difficulties to carve one. This is not a sad attack of modesty, but merely an attempt to show that one is always learning and that sculpting the human figure is not easy. People like Rodin and Michelangelo did nothing else for their entire working lives.

So, you are saying, 'How do I carve my own figure? I am not an expert on anatomy, and do not have a few years spare to become one. I do not have some compliant person who will model for me all day — and I do not want to carve figures like dressmaker's dummies that inhabit the anatomy books on the market.'

Let us suppose we are presented with the photograph Fig 232 from which we wish to make a carving. We therefore need to make drawings from all sides and, since this pose is horizontally rather extended, a top view. To do this we will need a simple drawing board, tracing paper and a square. Also the proportional drawings and the studies of skeletons and muscles, Figs 110, 111 & 112.

Proceed as follows:

Figure 232

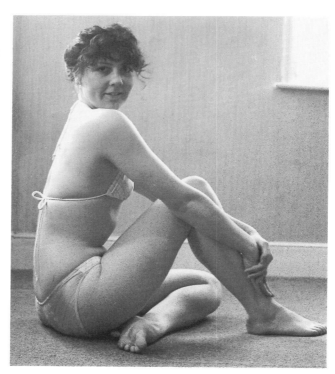

1. Carefully trace the photograph Fig 232 marking in significant features such as the elbow, knee-cap, ribs and ankle Fig 233a. Make a line for the centre line of the face, the eyes and mouth. Approximate the line of the skull. Then roughly draw in (using the skeleton drawings) the bone of the arm, legs, the spine, shoulder blade and ribs. The spine will be curving back, the pelvis tilted backwards and the shoulder blade pulled forwards by the arms.

2. Using a square extend lines downwards from the sides and centre line of the head Fig 233b. Draw a line X–Y at right angles to these lines. This is the centre axis of the body. Locate the top of the spine on the line X–Y, near the back of the head Z. Now draw in an oval for the top view of the skull.

3. From the proportional diagrams, we can approximate the width of the shoulder at ¾ of a head length — mark this dimension on either side of X–Y. The shoulders can be seen to curve forward from the spine just below head level. This curve can now be drawn in, Fig 233b and the shoulder joints indicated.

4. The arms curve forward from the shoulders to almost meet at the wrists. Extend lines downwards from the elbows and wrists in Fig 233a, and draw the upper and lower arms, as simple cylinders, as shown on the diagram Fig 233b.

Figures 233a & b

(a)

(b)

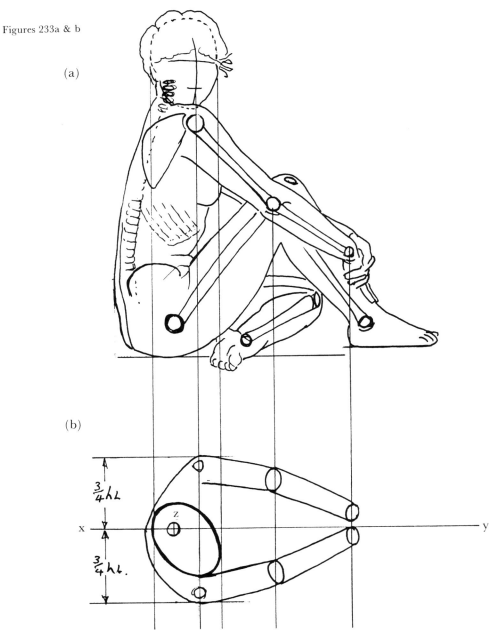

5. Referring now to Fig 233c extend a line down from the extreme point of the back and mark in the slight curve either side of the spinal groove Fig 233d.

6. From the female nude drawing, Figs 172 & 174, we can see that the hips are slightly wider than the shoulders in women. These measurements can be marked in. By studying the photograph Fig 232 we can see the hips are slightly twisted, since we can see across the back. Therefore we must establish this axis. The nearside hip joint will be just under the folds of the groin — extend a line down from this point. Now draw a line at a slight angle across the body to the other hip joint and mark this in. We can now draw in the curve of the hip area Fig 233d.

7. The nearside thigh can be measured from the hip joint to the kneecap. Using a compass, measure this length from the far hip joint and strike an arc in the area where the knee on the flattened leg will be, Fig 233d.

8. In the pose it will be found (by experiment) that the heel of the flattened leg is approximately on the centre line of the body X–Y. Extend a line down from the heel in Fig 233c and mark this. Now measure the length of the foot, mark this

Figures 233c & d

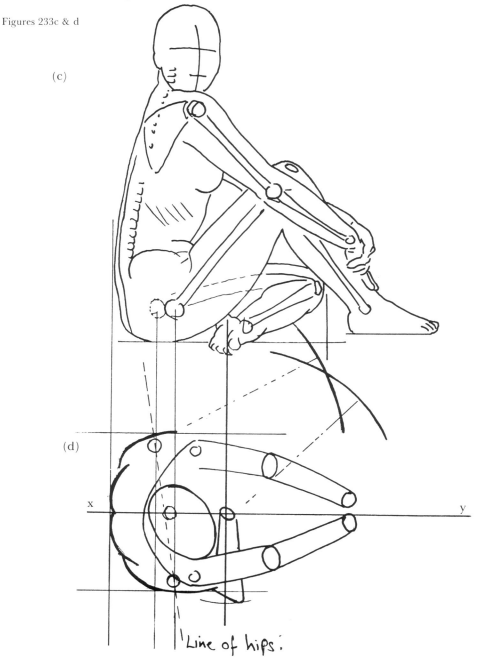

(c)

(d)

x y

Line of hips.

130

from the heel and draw it in Fig 233d. With the compass, measure the distance from the kneecap to the ankle bone on the nearside leg, and, using the ankle of the flattened leg as a centre, strike an arc intersecting the one made previously. This intersection is the extent of the knee of the flattened leg Fig 233d.

9. Draw in the thigh and the lower part of the flattened leg, Fig 233f.

10. Extend lines down from the upright knee and ankle. The knee joint does not bend from side to side so the line of the leg must go straight from the hip to the ankle. We can see that the knee projects between the forearms so the line of the leg is determined for us. Draw the thigh and lower leg, then extending a line down from the toe of the foot, draw this in also, Fig 233f. We now have a rough approximation of the figure seen from above. The next stage is to make the front view, using the top and side views together.

Figures 233e & f

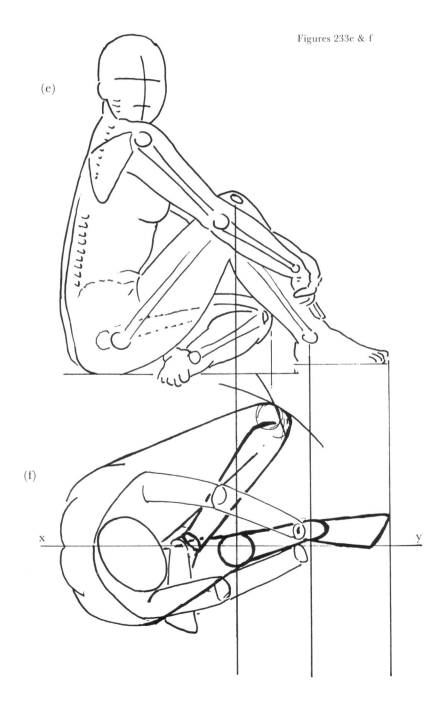

(e)

(f)

x y

131

Fig 233g shows our original side view.

11. Draw lines across from the top and bottom of the head, the eyes and the mouth, the knee and base of the buttocks. Draw a centre line at right angles to these, Fig 233h.

12. Draw in the head, using the top view for dimensions.

13. We know the thigh runs from hip to knee, mark in the knee and draw in the thigh, then mark the ankle and draw in the lower leg and foot. Measure all of this from Fig 233f.

14. Extend lines from the wrists, elbows and shoulders. Measure the shoulder width, then draw in the upper and lower arms, Fig 233h.

15. Measure the flattened leg and draw this in. We now have a rough front view. It will be seen that the head appears to be sunk between the shoulders, the nearside foot is off the ground and the flattened foot is below the ground. This is photographic distortion (see Fig 18 & 19) caused by the camera being too close at the height of the elbows — thus we are looking down on the foot and up at the shoulder.

Figures 233g & h

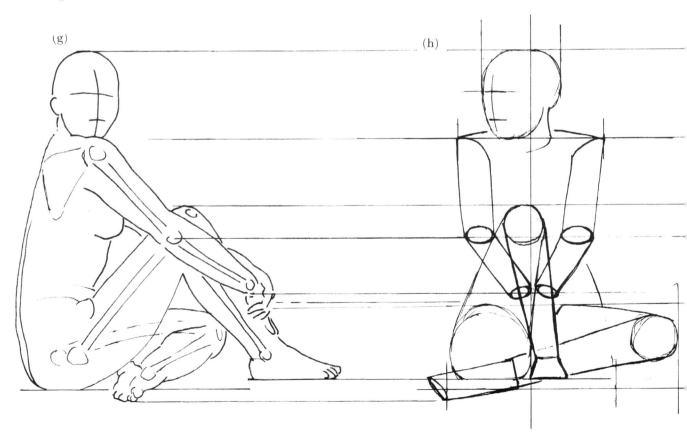

(g)

(h)

16. In Fig 233i the head has been raised slightly, the flattened leg brought up to ground level and the raised leg dropped to the same line.

The same procedure should be used for the back and far side view, using reversed tracings of the drawings we already have.

From now on we can build our figure using the skeletal and anatomical drawings to fill in the details, Fig 233j. Obviously, any other photographic or live reference material will be invaluable.

Figures 233i & j

(i)

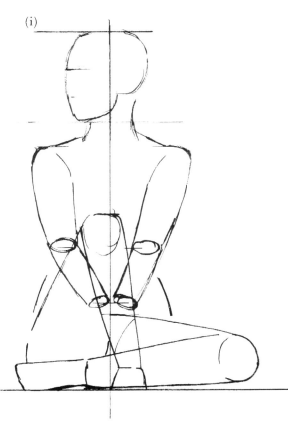

(j)

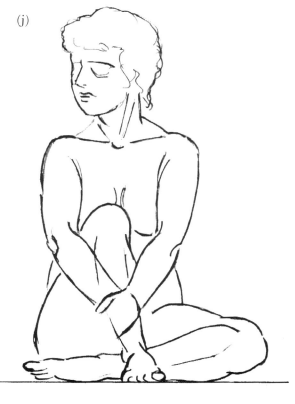

Having explained the possible process for creating working drawings from a photograph we must consider how to approach the problem of creating a figure radically different from those in the book.

The human body is virtually infinite in its variety, no book could give details of even a cross section. Just consider the possible stages of body development of a young man from emaciation, through thin muscular, fat muscular, very muscular, to grossly fat muscular (eg a Sumo wrestler) and all the stages in between. Then consider babies, children, teenagers, old people and so on, in every conceivable activity. What is the answer then, to the carver who wants to portray for example, a Sumo wrestler? First, he or she must have the confidence and some experience to depart from the standard (or classical) poses and normal, human body structure. Secondly, he or she has presumably obtained a picture of a Sumo to inspire his idea. Despite his bulk, the wrestler's skeleton and musculature remain the same as other peoples and the principles used in this chapter still apply. The difference is the huge quantities of fat and muscle. Pictures of Sumos are readily available in magazines and books, so it is simply a matter of applying this reference material to the normal body. In all cases you must have some original material to work from. You cannot simply make things up from your head.

So, to reiterate, from a live model, photograph at the very least four views (back, front, side and side); photograph as many reference positions as you feel will help you — remembering that you may not have the opportunity to have the services of the same model at a later stage. Photograph close-up details, in position, of hands, hair, ears, feet, eyes, etc; deal with the aspects of clothing — so, close-ups of folds, pulls, creasing, and so on. Make accurate drawings from your main photographs from the information given in Chapters 7 and 9. Make a clay model to help you. When you have done this and have ready all the reference material you can gather, go and buy a decent piece of timber suitable for the project, and start with confidence.

Working an idea from a single illustration is, as I have outlined, much more difficult but not impossible. Follow the guidelines in this chapter on drawing from a photograph. Then make your clay model and proceed as above.

Measured Projects

In order to help the reader progress from the detailed projects in the book so far, to the stage of being able to create his or her own from scratch, I have included the following section which consists of five projects which are directly related to the preceding ones. The poses are very similar so that experience and knowledge gained so far can be used and expanded. It is always difficult to carry out a carving from other peoples' drawings, another person's idea which he has researched, planned and worked through, then handed to you as if it were the simplest thing in the world. You may find that you do not really get the hang of the subject until you are half-way through it. Therefore, whilst the working drawings and photographs of the finished pieces are provided, it would be greatly to the reader's advantage to make a clay model before embarking on the carving. This will enable you to familiarize yourself with the shape of the figure

before carving and greatly facilitate the work. Most of the reference material you will need can be found in the rest of the book. If you have worked systematically through the projects, your knowledge of anatomy should be sufficient to enable you make the slight alterations needed to move a limb from one.position to another. Of course, nothing is as good as the real thing so you should make every effort to obtain the services of live models, even if only for faces, hands and feet. Collect any useful reference material you can such as photos, plaster casts of sculptures, original sculptures, medical anatomical models, bones, etc, and most of all, look at people more carefully, studying the way the human machine works. Finally, any of these projects can of course be altered or adapted to make a new design of your choosing. Indeed some of the photos of live models in this book have been used for several different carvings.

Old Man

Although very different in appearance to the male
head in Chapter 7, all the basic elements in this
portrait are the same, indeed the anatomical
structures are more clearly seen, and the features,
being more defined, are easier to carve. The
wrinkled texture of the skin is achieved by
numerous small shallow cuts with a gouge, whilst
the deep folds and fissures are cut with a knife. The
whole of the skin was subsequently scrubbed with a
wire brush, taking out the softer fibres of the wood
and increasing the roughness of the surface.
Figs 235a & b, Figs 236a, b & c, Fig 237, Fig 238.

Figures 235a & b

Figures 236a, b & c

137

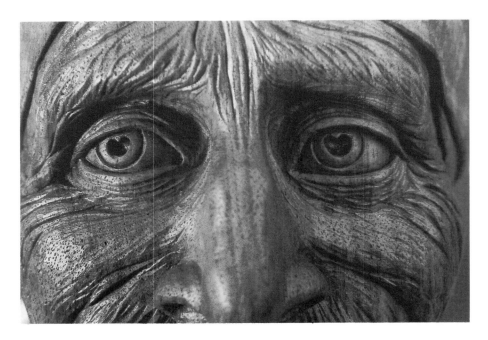

Figure 237

Figure 238

138

African Girl

This head is very similar to the female head in Chapter 8, except for the important point that the head is turned slightly to one side in the drawings. As was pointed out, this is considerably more difficult than when the head is presented full face on, but in this case it would have required a much larger block of wood. The first requirement, therefore, is to establish the orientation of the head in relation to the shoulders immediately after bandsawing. Once this is done, the shaping of the features can proceed in the normal way.
Figs 239a & b, Figs 240a–d.

Figures 239a & b

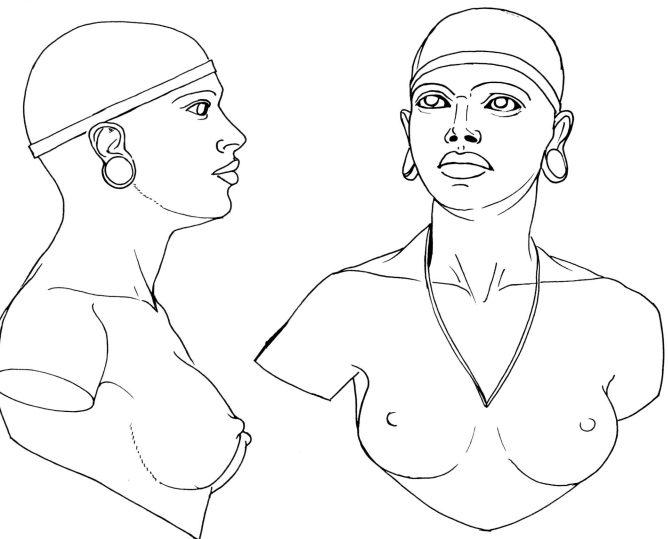

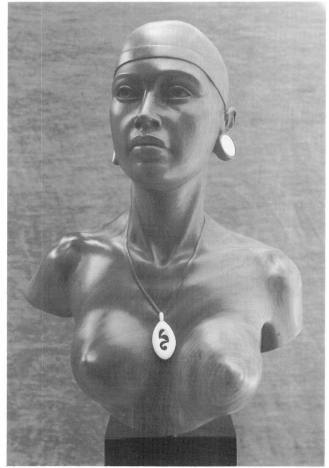

Figures 240a–d

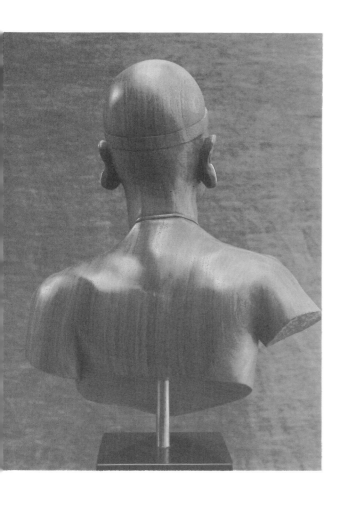

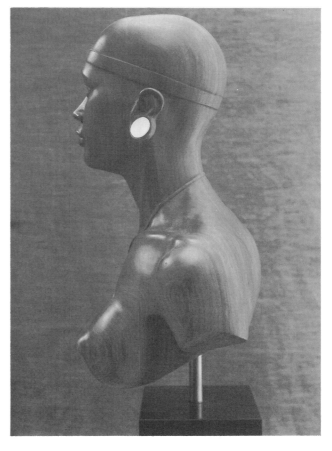

The Warrior

This figure is again posed very much in the
classical style and, because there are no extending
limbs, can be made from relatively small section
timber. Virtually all the detail of the body can be
taken from the detail on the Archer (Chapter 9)
and the head is shown in close-up in Fig 14. The
carved goat skin clothing is given a very finely
tooled finish, the cuts all running horizontally, to
give a wrinkly texture. The white material used on
the carving is bone, which works very well with
rotary burrs.
Figs 241a–d, Figs 242a–d.

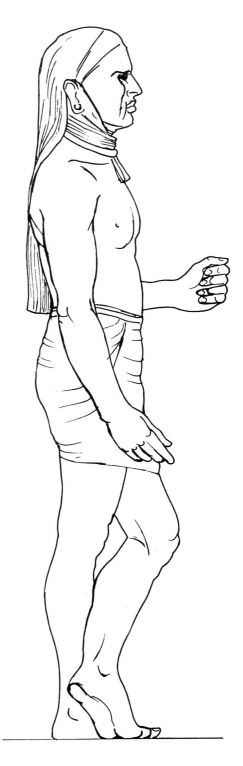

Figures 241a–d

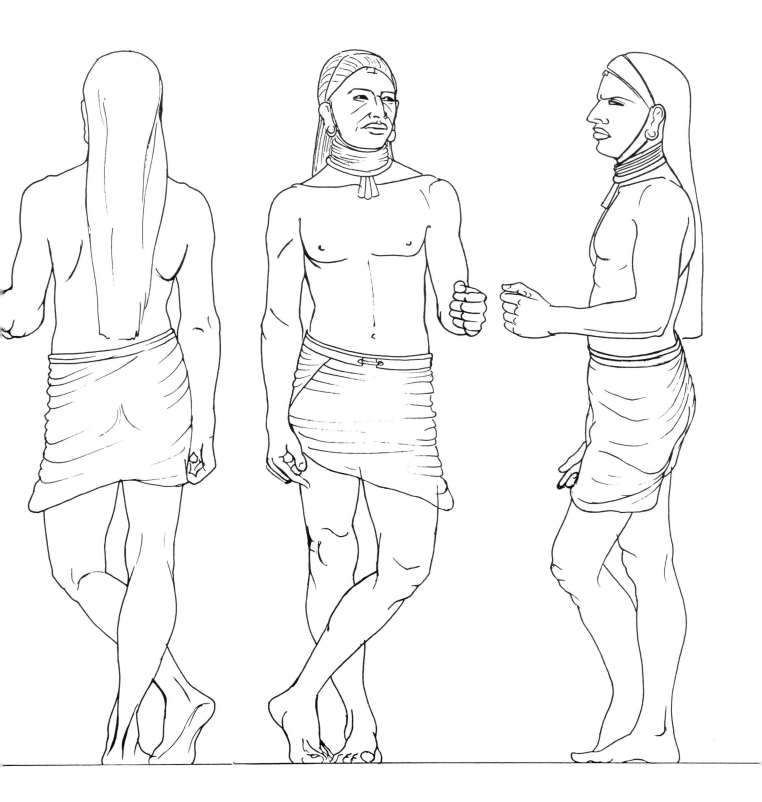

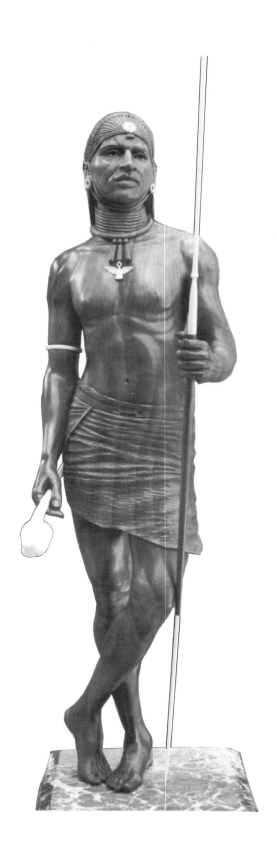

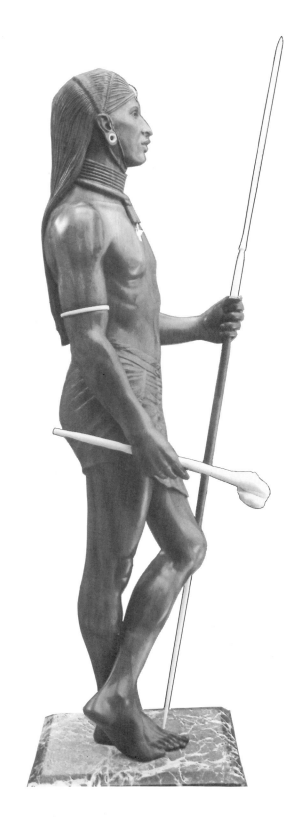

Figures 242a–d

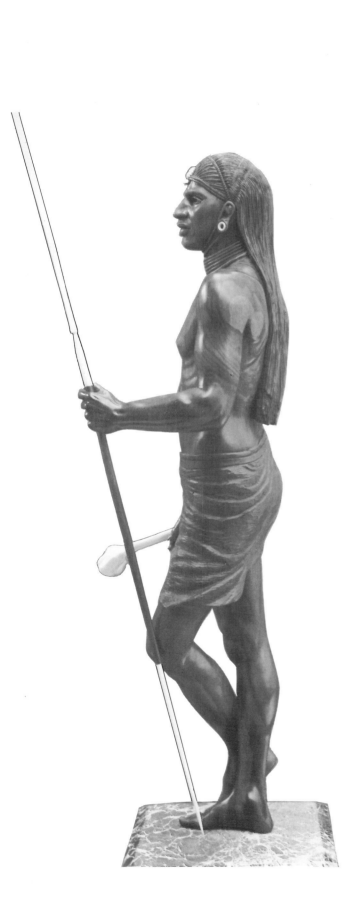
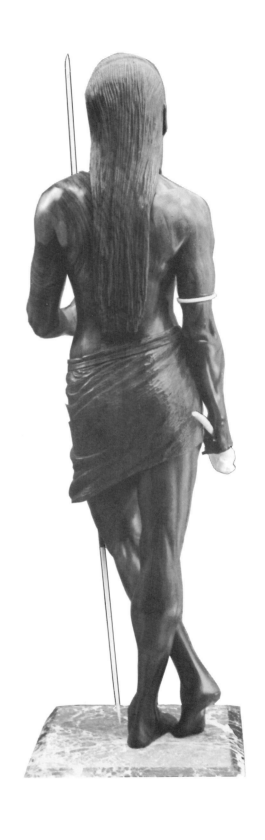

145

Classical Nude

In this figure the body has been lengthened from 7½ heads to 8½, giving a graceful stylization based on the paintings of the Pre-Raphaelite artist Edward Burne-Jones. There are no particular difficulties in this carving except perhaps fitting the hands to the copper ribbon, which, of course, the reader may wish to dispense with. As with all female figures, the musculature must be there, but very subtly carved. The hair is covered in detail in Fig 100.

Figs 243a–d, Figs 244a–d.

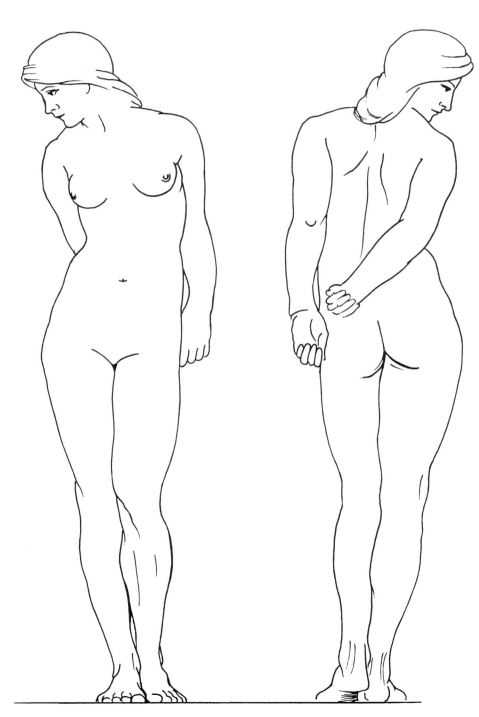

Figures 243a–d

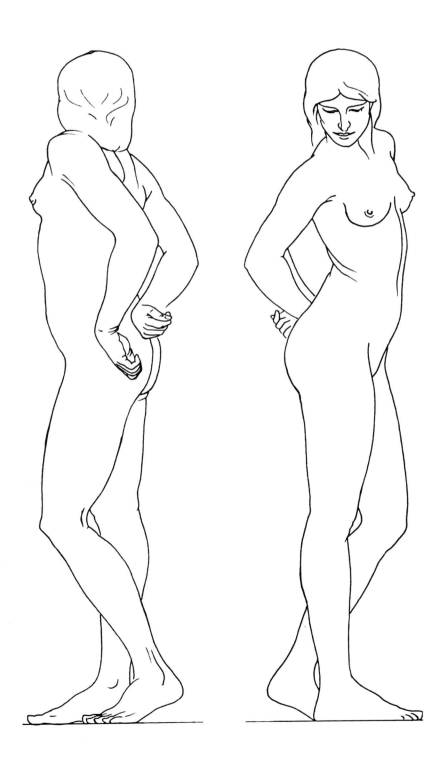

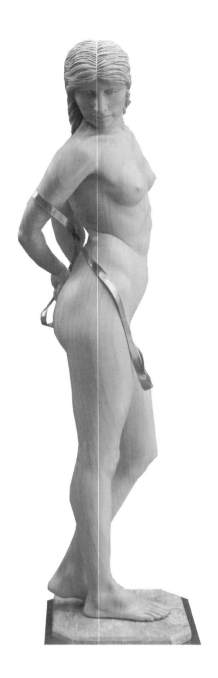

Figures 244a–d

Clown

This is a more difficult carving, having some sharp, awkward corners to get into, and deep folds and undercuts in the drapery. The inside surfaces of the clothes have been textured with a matting punch (available from carver's suppliers) which not only simplifies the problems of smoothing deep recesses, such as the sleeve openings, but gives an interesting contrast of surface. The glass can be made separately, and the pom-poms are textured with small burrs, like the Jazz Dancer's hair. The supporting wood around the foot must be left until everything else is completely finished, including polishing, and then the foot completed with the figure hand-held. When the carving is mounted, the leg is drilled through the heel and ankle and a strengthening rod glued in. Another rod is then inserted through the toe, up to the heel, and this is used to attach the figure to the base.
Figs 245a–d, Figs 246a–d.

Figures 245a–d

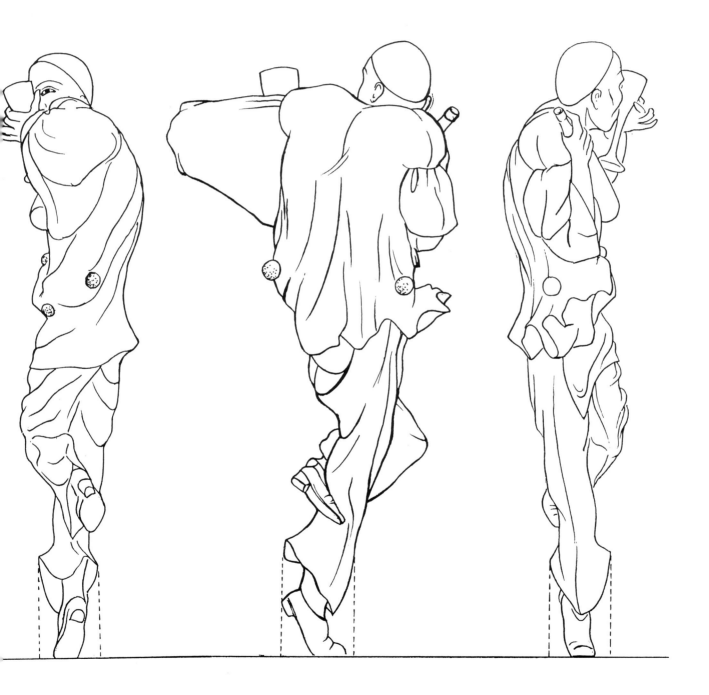

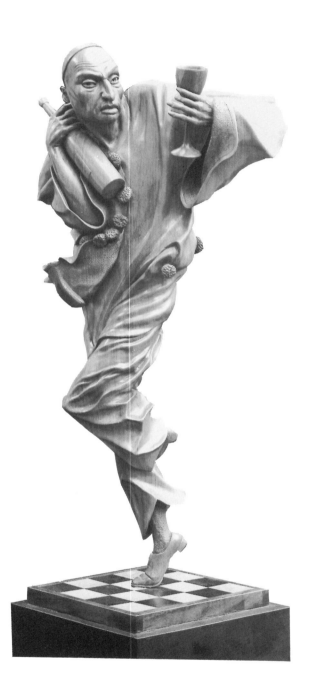

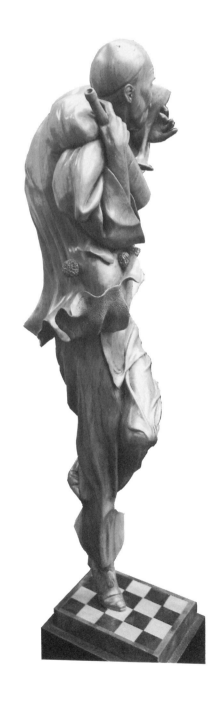

Figures 246a–d

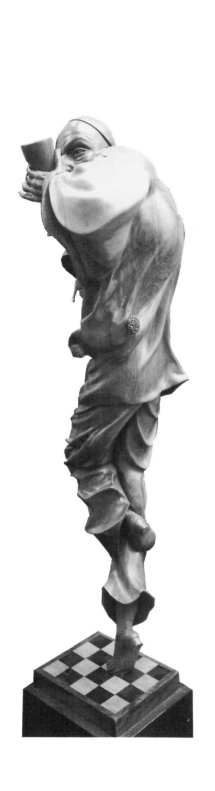

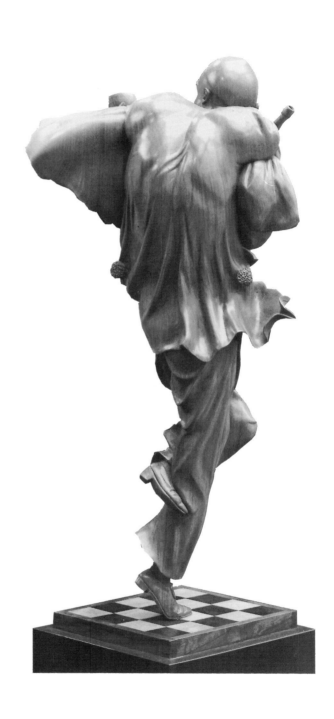

Posed Figures

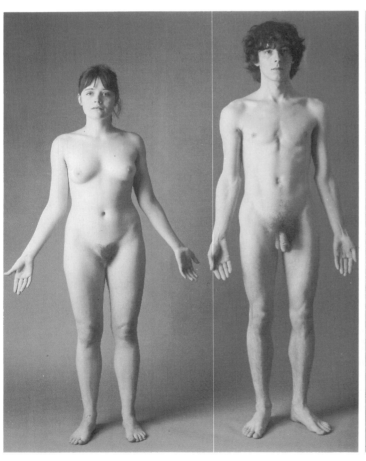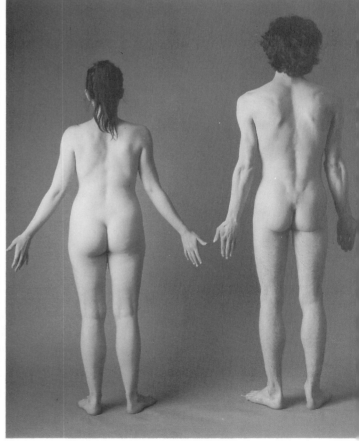

WHEN attempting to carve figures that are radically different to the accepted 'classic' poses different problems arise. To achieve the rhythm and movement of the dancing woman Fig 251 is as much an exercise in design and judgement as it is in carving, but it is also very taxing to actually cut the flowing lines of the hair and drapery. Very large blocks of wood are needed to carve the projecting limbs of a figure such as the kneeling girl, Fig 249, and the sitting girl, Fig 248, on a reasonably large scale. Also, the unfamiliar and transitory nature of some of the poses you may wish to carve makes it essential that you work out the problems in clay before carving. Bear in mind that sculptors throughout history have made the clay model or maquette an integral part of the sculptural process. I have included some photos of the basic nude figure to help you with future projects.

Figs 247a–d, Figs 247e–h, Fig 248, Fig 249, Fig 250, Fig 251.

Figures 247a–d

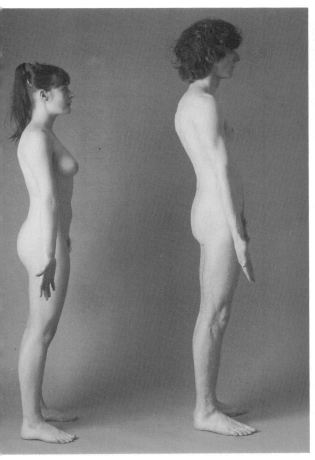
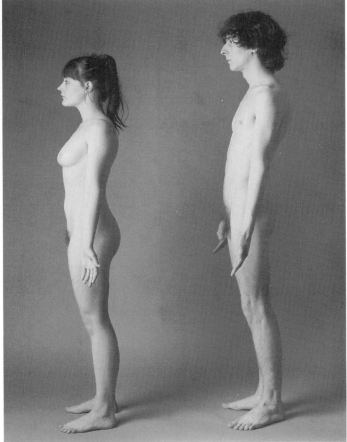

Figures 247e–h

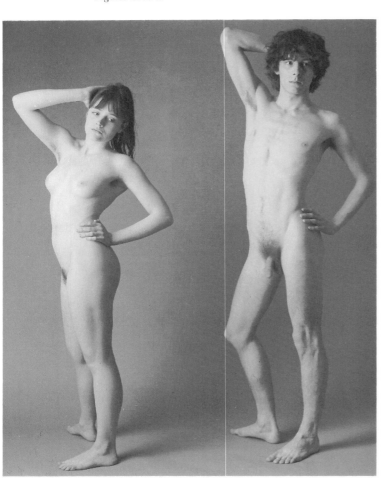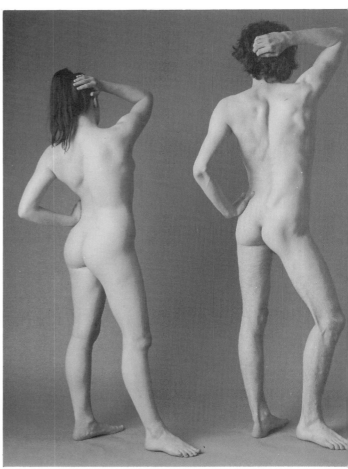

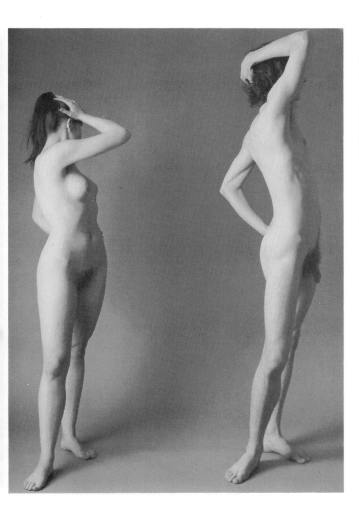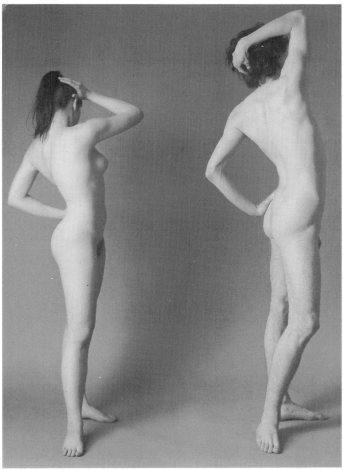

Figure 248

Figure 249

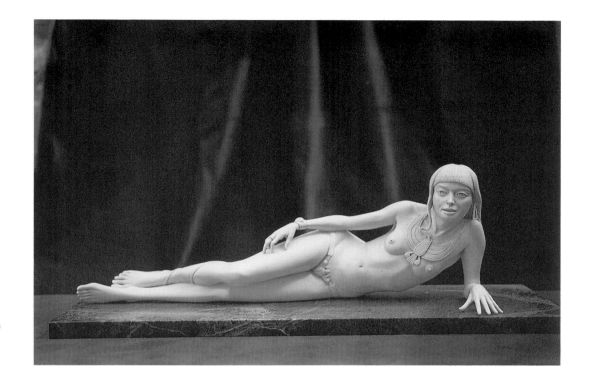

Figure 250

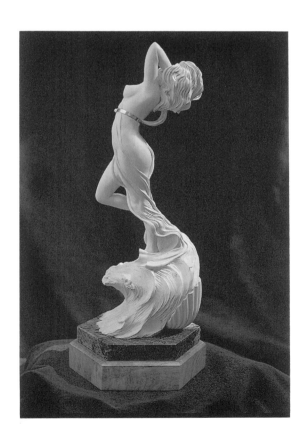

Figure 251

159

Bibliography

Stephen R. Peck, *Atlas of Facial Expression*. O.U.P., Oxford & New York.

John Cody, *Atlas of Foreshortening*. International Thompson, London; Van Nostrand Reinhold, New York.

Stephen R. Peck, *Atlas of Human Anatomy for the Artist*. O.U.P., London & New York.

Burne Hogarth, *Drawing Dynamic Hands*. Watson Guptill, New York; Phaidon, London.

Burne Hogarth, *Drawing the Human Head*. Watson Guptill, New York; Phaidon, London.

Thomas Easley, *The Figure in Motion*. Watson Guptill, New York; Phaidon, London.

Eliot Goldfinger, *A Guide to Human Anatomy for Artists*. O.U.P., Oxford & New York.

George B. Bridgman, *Heads, Features & Faces*. Dover, Mineola, NY; Constable, London.

Erik A. Ruby, *The Human Figure, A Photographic Reference for Artists*. International Thompson, London; Van Nostrand Reinhold, New York.

Bruno Lucchesi, *Modelling the Figure in Clay*. Watson Guptill, New York; Phaidon, London.

Bruno Lucchesi, *Modelling the Head in Clay*. Watson Guptill, New York; Phaidon, London.

Edouard Lanteri, *Modelling & Sculpting the Human Figure*. Dover, Mineola, NY; Constable, London.

Ian Norbury, *Projects for Creative Woodcarving*. Stobart Davies, Hertford; Macmillan, New York.

Fred Cogelow, *Sculptor in Wood*. Heart Prairie Press, Whitewater, WI.

Ian Norbury, *Techniques of Creative Woodcarving*. Stobart Davies, Hertford; Macmillan, New York.